PAINTING LANDSCAPES WITH WATERCOLOR

DESIGN
BOOKS
INTERNATIONAL

**PAINTING LANDSCAPES
WITH WATERCOLOR**
© 2001 by Design Books International

First published in Spain by
Parramón Ediciones, S.A. 1995
as PAISAJES A LA ACUARELA
Text, illustrations and photographs
© Parramón Ediciones, S.A., 1995
Text: David Sanmiguel
Artist: Vicenc Ballestar
Collection design: Toni Inglés
Graphic design: Josep Guasch
Photographs: Nos and Soto

First published in the U.S.A. by
Design Books International
5562 Golf Pointe Drive, Sarasota, FL 34243
E-mail: designbooks@worldnet.att.net

Distributed by
North Light Books
An imprint of F&W Publications, Inc.
1507 Dana Avenue
Cincinnati, OH 45207 USA
TEL 513-531-2222 TEL 800-289-0963

ISBN 0-9666383-6-0

05 04 03 02 01 5 4 3 2 1

U.S. Edition
Edited by Herbert Rogoff
Production by Stephen Bridges
Translated by Ellen King-Rodgers
Indexing by Ann Fleury

Printed and Bound in Spain

PAINTING LANDSCAPES WITH WATERCOLOR

Published by Design Books International, Sarasota, FL
Distributed by North Light Books, Cincinnati, OH

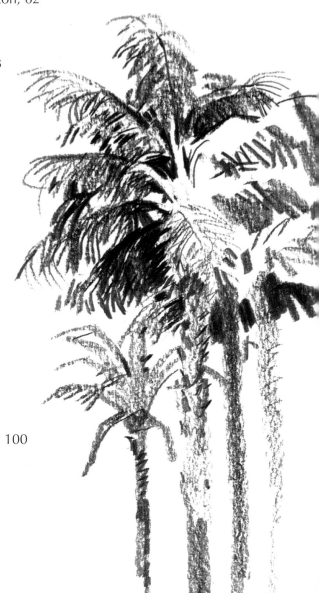

O f all the subjects that people want to paint, those associated with landscapes appear to be the most popular, which is puzzling because the art of landscape painting is one that is difficult and complicated. From the aesthetic point of view, there are very many details that one has to keep in mind: there's the color and color changes that are involved in outdoor painting, and we shouldn't forget the wide open vistas that face painters as they set up their easels. Then there's the ever-changing light which is a major factor and the difficulty in choosing a composition that contains a meaningful focal point.

But, like any painting, a landscape should be expressive. The artist must feel the panorama that is before him, that which generates an overwhelming desire to capture it in a painting. A cold winter landscape, though not equal to a luscious spring scene, can be just as compelling. And, too, the placid corner of a lake can be as important as a wide panorama of infinite horizon.

Subject matter abounds in the landscape genre; from the vibrant color of a countryside dotted with poppies to a mountain enveloped in mist in a melancholy, monochromatic day of rain. While the artist must confront the important differences of light, color, ambiance, etc., those factors inject into the artist's spirit some very different sensations: peace, sadness, optimism, romanticism.

Artist Vincenc B. Ballestar is the star of this book. He loves to paint landscapes and is well versed in the secrets and the craft of painting outdoors. He dominates the technique of watercolor and, with consummate workmanship, he knows how to squeeze out a multitude of chromatic possibilities.

His painting is full of a passion that only a veteran artist such as he can be capable of stroking onto his watercolor paper. The paintings of Ballestar go beyond the surface picture; they vibrate, they breath. They are the products of an exquisite and dedicated master.

In this book, the explanations, the experiences and the philosophies are accompanied by illustrations that burst with vibrant color. The step-by-step exercises that we have chosen to present to you are stunning examples of excellent instruction by a master teacher of the watercolor craft.

So, there you are! You are a watercolorist. You enjoy landscape painting. Get ready for a stimulating journey.

MATERIALS

A Look at Watercolor

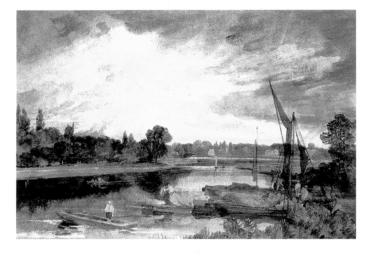

J.M.W. Turner, Scene on the Thames with Barges and a Canoe. British Museum, London. Turner was a great master of pictorial interpretation of watercolor landscape. He felt the basic techniques of the process, bringing them to a new level of expression.

Andrew Wyeth, Pirate Country. Norton Galleries, Palm Beach. Wyeth is one of the virtuosos of contemporary watercolor. His aquarelle style, radically different from his tempera paintings, is characterized by a spritely fresh appearance that pays special attention to the qualities and textures of the picture's theme. In works like this, the artist gave free reign to his subject and its color.

WATER AS THE MEDIUM

More than in any other painting medium, watercolor depends entirely on being diluted. Painting materials like oil, acrylic or pastel can be used full strength. In watercolor, this isn't practical.

Water is used to control the consistency of the color, its tone and its transparency. It is this dependence on water that makes watercolors a unique painting material that's capable of producing its own techniques. The amount of water that's required for watercolor painting makes it necessary to work on a support that has a degree of absorbency, enough that the color adheres and, at the same time, being capable of holding the many variations of strokes and washes that one can create with the addition of water, from a little to a lot. The paper is the ideal unique support upon which the watercolorist can work.

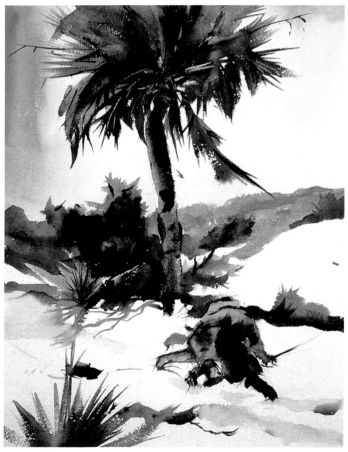

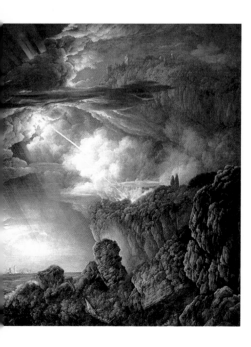

Abraham-Louis Rodlolphe Ducros, Night Tempest in Cefalu, Calabria. Cantonal Museum of Fine Arts, Luzanne. The romantic watercolor is characterized by a search of the dramatics of nature.

J.M.W. Turner, The Fire of the Parliament the Night of the 16th of October, 1834. British Museum, London. This work is a late product of Turner, when the artist moved beyond his time and seemed to directly connect with the impressionist movement that was to electrify the art world almost 30 years later.

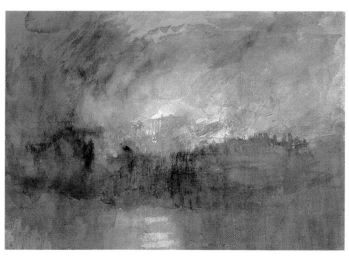

HISTORY OF WATERCOLOR PAINTING

The technique of watercolor painting, already known in ancient Egypt, had also been practiced by medieval illustrators of manuscripts. The genius of Albert Durer (1471-1528) took the process from book illustrations into a more general art which could serve for delicate studies of landscapes, plants and animals. Nevertheless, during the following centuries, watercolor continued its back-seat position to the dominance of oil painting.

At the end of the 18th century and principally in the 19th century, the golden age of watercolor developed in England Among its more famous practitioners were Cozens, Cotman and, above all, Turner. These artists excelled at capturing atmospheric effects of landscape through procedures that they adapted admirably. As hard as they fought to elevate the category of watercolor to a level that would be able to rival that of oil, these watercolorists were not recognized by the high artistic society until 1812.

During the 19th century, watercolors became more popular. From that point, the number of amateurs and professionals that had begun to regard watercolor as their exclusive medium of expression increased.

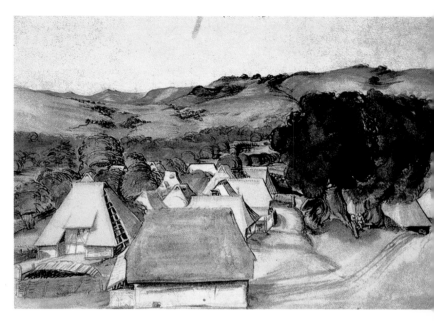

Albert Durer, View of Kalchkreuth. Lunsthalle, Bremen. One of the first artists to utilize watercolor as a serious painting medium for an interpretation of landscapes, Durer's landscapes and his watercolors weren't regarded with any importance at that time. It would have to wait until well into the 18th century for watercolor landscapes to receive any attention from collectors and galleries.

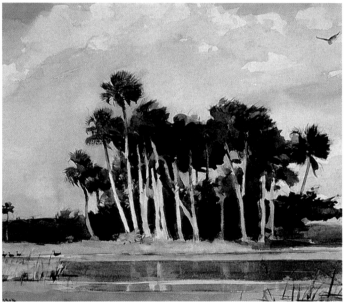

Winslow Homer, Ring of the Bermudas. The Brooklyn Museum, New York. The work of Homer is now a classic of modern watercolor. Homer continued in the landscape tradition and gave it new impetus thanks to the paintable locations that he discovered in special places in the United States. His style is one of vigorous realism and his technique is truly refined. The contrasts of pure color are always present, as reflections, transparencies and delicate washes of color. His watercolors are the epitome of profound technical knowledge and his skill of observation is unmatched.

THE WATERCOLOR PROCESS

Different from oil, watercolor, which is bound in gum arabic, a coloress medium, produces clear, bright colors. If the paint is applied to the paper while it is still damp, the resulting effect is an explosion of bloomed color that creates an appearance that you simply can't get through the use of oil colors.

Watercolor techniques do not make use of any opaque color applications even though opaque colors, such as the cadmiums, etc., are used. With watercolor one could get varied effects that go from the use of the texture of the paper for effects of dry brush to the use of items like sponges, rubber eraser, sandpaper, and other devices that may alter the texture of the painted surface.

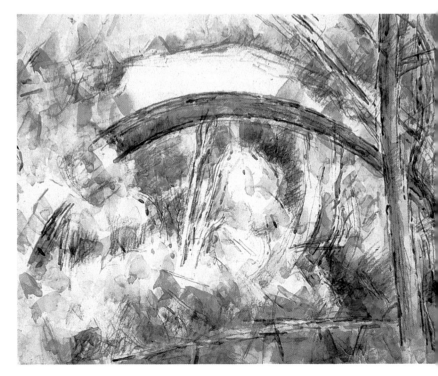

Paul Cezanne, The Bridge. Cincinnati Art Museum. The watercolors of Paul Cezanne have been celebrated for the subtlety of their color and the solidity of the construction. The artist's slow and deliberate light touches dried before he superimposed the next touches. These works have an unequaled transparency and at their time opened new roads for pictorial interpretation of the landscape.

Types of Watercolor

WHAT ARE WATERCOLOR PAINTS?

The colors used for a watercolor palette are the same pigments that manufacturers use for all their other artist paints. It's the binder that's different. The popular binder for oil paints is linseed oil, for acrylics it is a plastic resin, for pastels it's an aqueous binder that evaporates. Watercolors are bound in gum arabic, which makes it possible for the colors to adhere so tenaciously to the paper.

Watercolors are manufactured in four varieties: dry watercolor in cakes, semi-dry in cakes, soft watercolor in tubes and bottles of liquid watercolor.

DRY WATERCOLOR IN CAKES

The colors of dry watercolor are usually associated with inexpensive watercolors. They come in little round cakes that you must moisten with a wet paintbrush to get any color. These watercolors are, in most cases, scholastic quality which is not used for serious work. The colors are low quality pigments and the binders with which they are mixed are very poor. As a result, colors are not consistent and when dry, the results are unstable.

Almost everyone started to paint in school using scholastic water-colors. They come in boxes of metal or plastic, and contain round cakes of dry watercolor. Outside of a few exceptions, watercolors of this type tend to be mediocre.

Replacement of watercolor cakes is economical and they are convenient to carry. Artists find these colors are handy to have for small drawings or preliminary sketches to prepare them for larger, more important works.

DAMP WATERCOLOR IN CAKES

The damp watercolors in cakes are small rectangular pans of white plastic and are of professional quality. The little cakes dilute rapidly, and are more viscous than the dry watercolors. Since the manufacturers use pigments of the finest quality, the prices vary according to the colors and the cost of the pigments used.

The cakes dry after use, which makes it easy to take with you on painting trips.

The damp cakes of watercolor are made by important manufacturers such as Schmincke, Winsor and Newton, Talens, and others. They produce colors that have excellent color coverage.

We see below a tube of water-color, the most popular of all watercolor paints. The tubes are of various qualities and prices but they all offer excellent perfor-mance. To keep the color fresh in the tubes, wipe them clean and seal each one well after use.

Liquid watercolor, seen here, comes in small bottles that contain droppers in their caps. This dropper is very useful to fill an airbrush, a tool used by illustrators. Many liquid watercolors are dyes, which are not conducive for fine art painting. The difference between a paint in a dye and a paint in a binder is that a pigment dissolves in a dye but a pigment and its binder are held in suspension, forming what we can call a paste-like product.

BOTTLES OF LIQUID WATERCOLOR

Used almost exclusively for commercial illustration, they are very useful for effects that are not what we call permanent. The colors that are packaged in bottles would not ordinarily stand up to any exposure of strong light. Liquid colors are ideal for use with an airbrush. The bottles have a dropper in the lid to make it easy for the artist to fill the reservoir in the airbrush. Most liquid watercolors are dyes; they are not recommended for fine art painting because a lot of these colors are fugitive.

CHOICE OF WATERCOLOR

As I said earlier, professional watercolorists paint with watercolors in tubes. You will find colors that cost a little to those that cost a lot. The factor that determines this is the amount of filler (or extender) that is used for each quality of paint.

Chinese White is an opaque color, similar to gouache. Some professionals use an opaque white to cover up mistakes. Watercolorists who are purists have always frowned on the use of white, but today, these one-time taboos have disappeared. Gouache, incidentally, is opaque watercolor because it contains white which the manufacturer creates by adding white (blanc fixe) to the colors when manufactured.

WATERCOLOR IN THE TUBE

These colors dissolve very easily with water and permit you to work with a great amount of intense color. To use the tubes, the watercolorist uses palettes with little wells for the color. Once the colors have dried in the wells in the palette, it's easy to wet them up again. It's not necessary, therefore, to clean the wells after each session and thus waste expensive paint. The precaution you should take with tubes of watercolor is to keep the color from drying inside the tube. Capping each tube tightly helps.

Shown below are tubes of watercolors made by a leading manufacturer. Most makers of fine art supplies feature an excellent line of tubed watercolor.

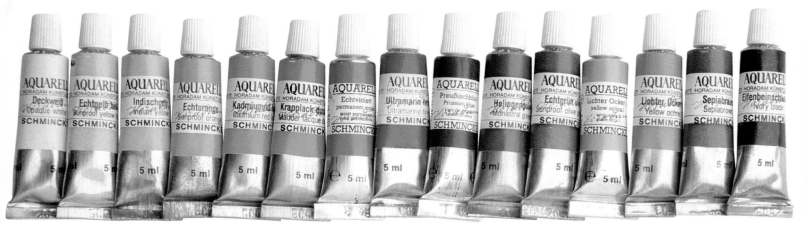

Watercolor Sets

ASSORTMENTS AND PRESENTATIONS

Damp watercolor cakes are packaged in metal boxes that generally serve as palettes. They are manufactured by companies that are known for quality: Winsor & Newton, Talens, Schmincke, Lefranc Bourgeois, are some of them. All these manufacturers also make watercolors in tubes. Watercolor paints are sold in tubes that the artist buys either individually or in sets of different sizes.

In some of these sets you might see a tube of Chinese White. The majority of professionals (largely the purists) don't use opaque white; academically it is "prohibited," but some watercolorists will use it for touch-ups.

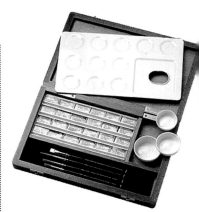

Here is a case of quality watercolors, a palette with wells and a selection of paintbrushes including sable and synthetic hair.

COLOR SELECTION

Color charts are invaluable to the artist for buying the colors he will need for his watercolor paintings. In order to paint many kinds of pictures, it's not necessary for each artist to have all of these colors. From the color chart, the artist will select his palette of colors — the ones that work best for him. Winsor & Newton, for example, offers a total of 89 distinct colors.

In all color charts you will find information about the permanency of each color, from the most fugitive (little lightfastness) to the most reliably permanent (stable). Most colors are permanent; others offer a minor degree of permanency when the watercolor is exposed to light over time. This information is clearly indicated on each color chart.

The charts also indicate which colors are semi-opaque, semi-transparent and transparent. While it's true that the addition of water will make all colors transparent, the pigments that are truly transparent will have more luminosity when the white of the paper shows through the washes. Washes of Alizarin Crimson, for instance, will glow more than those of Cadmium Red.

The set shown here is a deluxe selection of materials to paint watercolors. The colors are predominantly damp watercolor cakes, there are quality paintbrushes, and palettes for mixing colors.

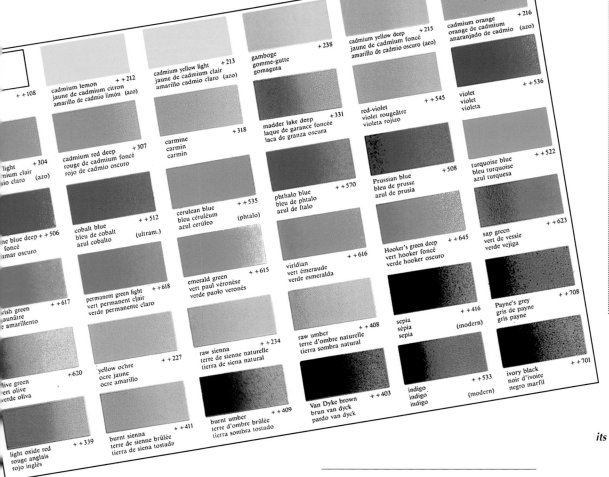

A color chart of Schmincke watercolors: 36 colors to choose from. The chart shows each color in its mass tone and when water is added.

The watercolorist can buy many kinds of palettes: plastic, porcelain, or metal. Any material but wood can be used as a palette for watercolor painting.

Manufacturers offer a great variety of watercolor assortments in boxes. Most of these contain 36 colors, more than enough for any work, and a good area available for mixing. Smaller sets provide 26, 12 and 8 colors. These sets are ideal for sketching on location.

ALL KINDS OF PALETTES

The majority of boxes to house your watercolor paints also serve as palettes on which to mix your colors. These boxes are made of white enameled metal with wells to hold colors. There is also ample space for mixing. Many of these palettes have a hole or a ring in their lower part for the artist to place his thumb. Of course, if you want to save money, you can use a white porcelain plate on which to mix paints. You'll also find that scraps of watercolor paper come in handy to check your mixtures before committing them to your painting.

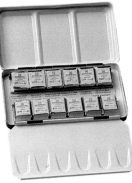

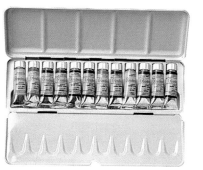

We see here a number of sets that show a variety of colors that are normally used by watercolorists: Lemon Yellow, Cadmium Yellow Medium, Van Dyke Brown, Sepia, Cadmium Red, Permanent Green, Emerald Green, Cobalt Blue, Ultramarine Blue, Prussian Blue, Payne's Gray and Ivory Black.

Watercolor Paper

QUALITIES OF PAPER

In watercolor painting the quality of the paper is most important. Dealers' shelves are stocked with inexpensive grades of paper that we classify as scholastic quality. These papers are processed from wood pulp and are machine-made products. You will find them ideal to practice on and to use for other watercolor projects.

Professionals, on the other hand, demand papers that are finer and, I might add, far more expensive. These products are made of 100% rag, either linen or cotton, and made by hand by time-honored manufacturers around the world, principally in Europe. The names of these makers are respected by professional watercolorists: Fabriano, Arches (making paper since 1492), Whatman, are just a few of them. These paper makers produce other grades, too, but even their intermediate qualities are very acceptable by painters.

Shown here are samples of fine papers displaying their water-marks and embossed logotypes. The papers for painting water-colors are supplied in single sheets, in pads and sheets bound in blocks and in an array of weights and sizes.

To distinguish watercolor papers of quality, each manufacturer imprints its mark of manufacture in each of the sheets. These marks are visible when held to the light. The presence of the watermark or embossed seal is, in effect, your guarantee of quality.

Incidentally, the side upon which this can be read is usually the right side on which to paint.

GRAIN OF THE PAPER

Watercolor paper is basically made in three textures or finishes: hot pressed (smooth), cold pressed (medium grain) and rough (heavy grain). Hot pressed paper, with hardly any texture, is not suitable for transparent watercolors where a lot of water has to be used for many washes. It is not as absorbent a sheet as the other textures you can use. Hot pressed paper works well with gouache and other opaque

The most popular way to buy paper is in blocks of 20-25 sheets that are backed by an extra-thick board. It's easy to carry, your sheets will not warp and the heavy backing functions as a good support upon which to paint. After you paint on the block, and after the painting has completely dried, you free up the painting from the block by cutting around it with a knife.

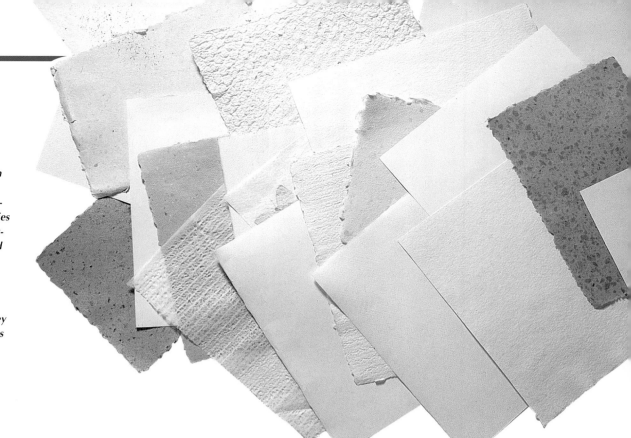

Today there are many different papers from which to choose. Quite popular are the papers from Asia, especially Japan. Japanese paper is spongy, fine in texture and absorbent; it is the traditional paper used for watercolor in Japan and other countries of the world. It becomes impregnated completely with color and permits a saturation of tones. Because of this, it is difficult to control the strokes. You'll find other types of paper that are made by hand in small mills; they are sold in varied formats, colors and textures.

watercolor paints (tempera and acrylic), as well as providing a sympathetic surface for pen and ink renderings.

Medium grain paper—cold pressed—provides a texture that works beautifully with transparent watercolors. This grade, without a doubt, is the one that's preferred by most painters.

Rough grain paper offers a very rugged texture. Rough paper produces brilliant effects but because of the extremely rough surface, it is not the easiest to paint on. All of the three types of paper come in a variety of weights with 300 lb. being the heaviest. The weight of watercolor paper is based on how much a ream of 500 sheets weighs.

PAPER SURFACES

All these papers have a right side and the reverse. Obviously, the good surface offers a better finish. To distinguish between both surfaces it is necessary to be able to tell the difference between the irregular grainy characteristic of the reverse side and the more regular and symmetrical texture of the good side.

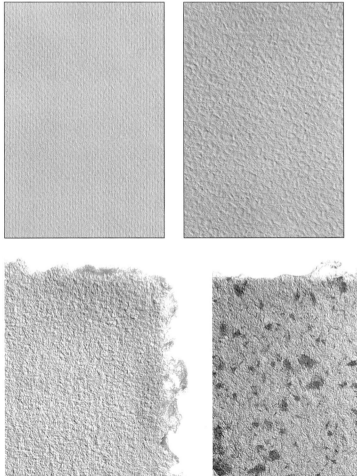

You can tell the papers that are made by hand; you'll recognize them by the irregularity of the fibers that make up their textures. The grain or texture of the paper is a determining factor in the way your watercolor will look. Paper of fine grain (hot pressed) creates bright and transparent color but you can't get any great saturation. The rough texture may not be as brilliant but its texture makes it possible for the artist to produce dramatic works of virility.

Preparation of the Paper

THE PAPER IS THE PAINTING

Unlike artist's canvas, whose only function is that of a support for oil colors, watercolor paper plays a much larger role. It is a vital element in the creation of a watercolor painting because the paper is the painting. For this reason, the painter takes great care to prepare the paper to meet extremely rigid standards. From immersing the paper in a bath full of water to scrubbing the manufacturer's sizing off with a sponge to using gesso to create a new surface, the painter can be quite neurotic about the surface that will become his painting. Also included is the way the painter secures the paper to the board, either spanning it over stretchers or tacking or taping the paper to a board.

If you paint on heavy paper, such as a 300 lb. sheet, tension isn't necessary. Thumbtacks or clips will do nicely. In lighter full sheets, the artist can span the paper over a frame.

SECURING THE PAPER

If you want to paint on a full sheet of paper that's lighter than 300 lb., you have to secure the paper to prevent any possibility of warping. To tighten a sheet of paper it is necessary to lay out a board that's larger than the paper and tape the paper to it. Before you do this you will have to dampen the paper on both sides with water; you can do this with a sponge or by placing the sheet directly under the tap until it is completely saturated. Then, arrange the paper over the board and adhere it by means of four strips of gummed sealing tape. Once it has dried, the sheet of paper is ready for your masterpiece.

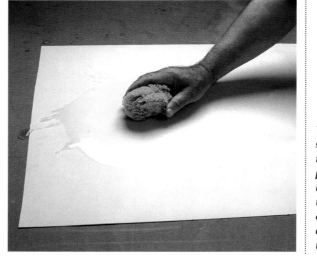

The process of tightening the sheet of watercolor paper over a frame begins with moistening the paper with lots of water, continuing by centering the frame over the sheet and folding the margins over the wood. Each of the doubled margins is adhered to the frame with tacks or clips.

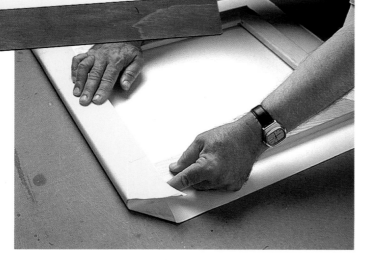

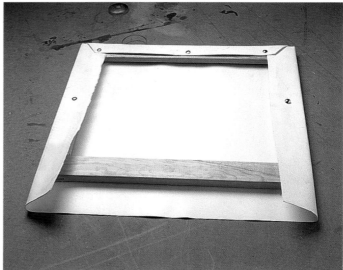

Painting over tightened paper will eliminate the problem of warping. Although using a lot of water will slacken the paper, upon drying it will be completely tight again. Once the work is finished, cut the sheet free with a knife. You may remove the tape from the margins of the painting, but do so carefully.

Another method of paper preparation is to cover your paper with gesso prime that contains white (pictured below right).

The gesso reduces the absorbency of the paper, at the same time increasing the whiteness. With gesso on the paper, there would be no need to span it over a frame or to mount it on a board.

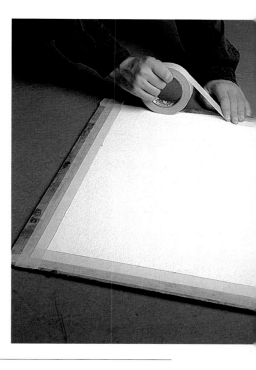

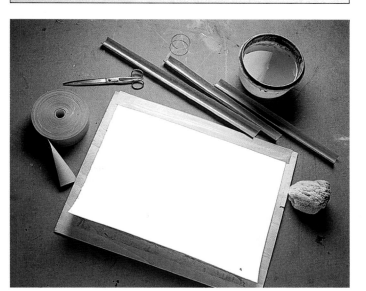

TO TIGHTEN OR NOT TO TIGHTEN

When paper tension is desired without going through the elaborate procedure, you can secure it to the board with masking tape (shown above). Also you can hold the paper down on the board by using push pins or tacks, which would be more like fastening than tightening. In any case, it all depends on whether the painter wants to work on perfectly smooth paper or on paper that has some slack in it. Some artists prefer this last option and for that they will paint without any previous preparation of any kind on the paper. What's more, some enjoy using heavy, hand-made paper that is extremely rough.

VARNISHING

At your art materials dealer you may find a type of varnish for watercolors. Many watercolorists do not use it because the varnish may upset the characteristic matte finish of a watercolor painting.

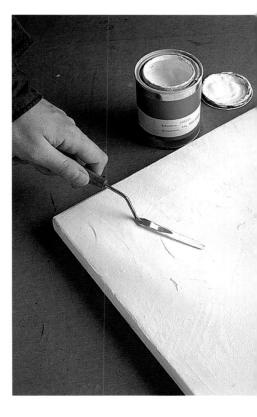

Watercolor paper, you will find, is an extraordinary material that doesn't deteriorate easily, unless it is deliberately cut or torn. Under normal exhibition conditions, it will hold up very well as long as the front and back of the framed picture has been made airtight. It is advisable not to expose your painting to extreme sunlight or heat.

Paintbrushes

TYPES OF BRUSHES

Watercolor brushes do not take the punishment and abuse that brushes for oil colors and especially for acrylics do. For this reason, you can afford to spend that extra amount of money to buy these ultra expensive red sable brushes, principally those in the larger sizes. After all, brushes of red sable are the very best.

Along with red sable, you will need other soft brushes, those made of oxhair (from their ears) and from squirrel. These brushes come in all shapes: round (pointed), flat (chisel-edged) and what is called a mop, thick and full, usually of squirrel hair.

The feature of watercolor brushes is the spring of the hairs. This resiliency is at optimum for red sable brushes with reduced spring (or snap) in other hairs. Oxhair, when wet, has a tendency to "drag," which a lot of artists like since this gives them better control. The mop, too, gets a bit soft and sloppy when filled with color, and this is a plus factor. It's great for big areas such as skies, oceans and so on.

The Japanese *Hake* (pronounced hockey) is also good for covering large areas, but this brush is largely used in oil painting as a blender.

Synthetic hair is touted as a suitable brush for watercolor painting, but brushes made of this material do not hold as much water and paint as natural hairs do.

As with the rest of the materials for watercolor painting, the quality of brushes is judged by how they respond to water. This response is based on the brushes' capacity to hold a good amount of color, how well they hold their shapes after each painting, and the integrity of their points.

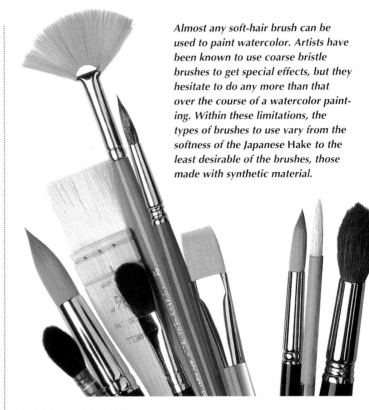

Almost any soft-hair brush can be used to paint watercolor. Artists have been known to use coarse bristle brushes to get special effects, but they hesitate to do any more than that over the course of a watercolor painting. Within these limitations, the types of brushes to use vary from the softness of the Japanese Hake to the least desirable of the brushes, those made with synthetic material.

SELECTION OF BRUSHES

Originally, synthetic hair brushes were readily accepted. Today, it is a rare watercolorist who uses them exclusively. While they are very tough and durable, they clean with difficulty. In round hair brushes they are inconvenient because they do not come to a sharp point. Furthermore, there is a tendency among many synthetics to flay at the edges thus cancelling them out for any serious painting. Synthetic brushes will never perform in watercolor as red sable and oxhair brushes do. As for mops, it appears that the only material for these great brushes should be made from squirrel hair.

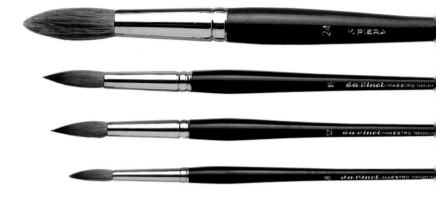

On the right we see a selection of oxhair brushes (numbers 4, 6, 8, and 21). On the left we show you the way to clean a brush. Use soap and rub the brush against your palm until the water is completely clear. This is not necessary if the brushes have been rinsed well during the painting sessions, removing any paint in the hairs.

SIZES

Brushes for watercolor painting are available in a number of thicknesses; they are numbered: 00, 0, 1, 2 to 24 for the oxhair. These numbers are stamped in the handle of the brush. To paint with watercolor, three red sable brushes are enough (sizes 8, 12, 14) and one or two of the chisel-edged oxhair, size 24 or larger.

Below is a chisel-edged brush with a bevel at the end of the handle. This type of brush, made in both red sable and oxhair, makes it possible for the artist to scrape the beveled handle over the wet paint, thus creating a variety of textures in the painting.

On the right is shown the way to carry brushes: rolled in a piece of cardboard around them and held together with a rubber band.

Below you can see a complete series of red sable brushes, from the smallest, 00, to the largest, # 24.

CARE OF YOUR BRUSHES

A good red sable brush can last for years if you take care of it. There are some rules that you should be aware of. In the first place, don't lay the brushes in a pan of water with the handle under the level of the water. I don't have to tell you how this can damage the entire brush. Some watercolorists use a brush holder, a spiral made of aluminum. The spiral holds the handle of the brush while the hairs of the brush rest in the water. You may also lay your washed brushes on a towel on your taboret.

After each painting session, wash your brushes, if necessary, with soap and water, rubbing them with your fingertips to reshape the points. The brushes should be stored with the hairs facing up. To carry brushes, wrap them in cardboard holding it fast with a rubber band.

Quality brushes last a long time if they are treated with great care.

Additional Materials

ACCESSORIES

Apart from the basic materials, like colors, brushes, paper, etc., watercolor painters have to use other items. In the first place, they need pencils to make the drawing on the paper. Along with them, a soft eraser is necessary, also a straight edge or T-Square and a mat knife for cutting paper down to various sizes. Most important are containers for water; they should be large with wide mouths. It's a good idea to have two of them to make sure you always have clean water.

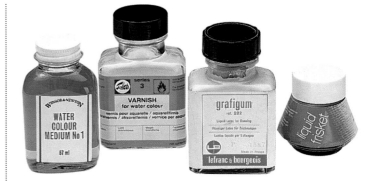

Pictured above and below are mediums, varnishes and fixatives that are designed for watercolor painting. They are used infrequently, but some artists enjoy giving a final touch to their work in order to protect them from dust and dampness.

Not entirely necessary at this point are masking friskets that are shown here. These are bottles of thinned rubber cement that artists use to paint areas they want to be masked out. After you paint over these masked areas, you remove the cement and the paint over it leaving areas of white paper.

MASKING FRISKET

Since the use of opaque white is not accepted in transparent watercolor painting, the way to leave certain small areas of white is with the use of masking friskets. You paint with the frisket, which is a form of a thinned down rubber cement, the areas you want to be masked. When those areas have dried, you paint your watercolor over them. After the watercolor has dried, the frisket is rubbed away with fingers or an eraser, and the areas remain white. This is ideal for painting fence posts and pickets and also for birds in flight in a painted sky. Make sure you use old, tired brushes to apply the frisket because the dried rubber is hard to get out of brushes.

In your studio you can use glass as water containers. Outdoors, you may want to switch to plastic. In any case, don't use any container that's smaller than a quart size.

Paper is secured to a board through the use of different types of fasteners, from large metal clips to clothespins. It's wise to have enough of these devices, many of which are shown in the illustration at right.

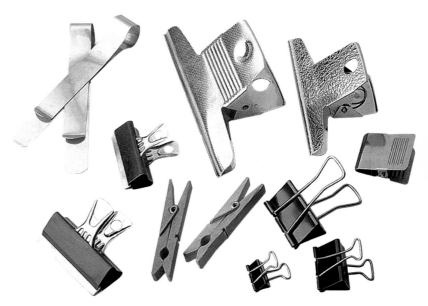

MEDIUMS

The word medium has confused a lot of people. First, it's used to describe the kind of paint being used—oil, watercolor, pastel, acrylic—and it takes the plural media. Medium is also used to refer to the products the artist uses to mix with paints—more in oil painting than watercolor. This takes the plural mediums.

VARNISH

Almost all the major brands of materials sell a varnish especially for watercolor. Some artists may use it to protect and give brilliance to the colors, applying it in light touches and only in certain areas, especially in the darker colors. Only in rare cases are varnishes used.

India ink and Chinese ink sticks are used by some watercolorists for drawing that they want to show in the finished work. Here, too, this is not a general practice.

Among other accessories are sponges and paper toweling. To accelerate drying, some artists make use of a hair dryer in their studios to dry sections of a painting to save waiting time.

In the Studio

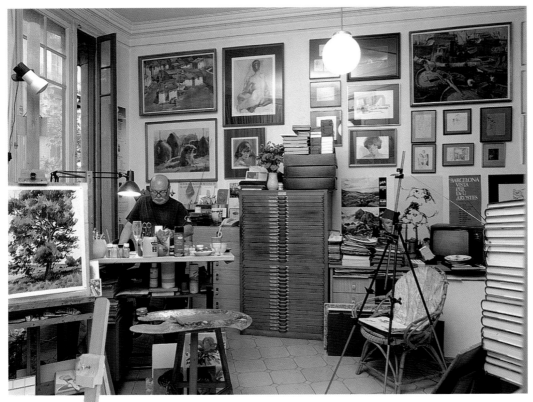

THE WORK SPACE
Although landscape painters should try to always work outdoors, they should have their studios for drawing and painting from sketches or drawings made from nature. All the studio needs is a large table to work on, a stool and some file drawers to store the paper. If there is extra space, it's wise to have an easel in the studio.

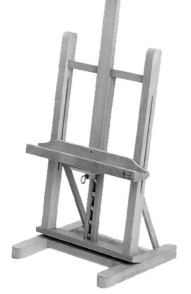

LIGHTING
Your workspace should be situated in a way that natural light comes through a window that's to the left or right with blinds or curtains to regulate how little or how much light you want. You will need artificial light to balance the natural light. To get this, you can install fluorescent tubes in warm and cold tones to simulate natural light.

The table easel is very useful for painting small watercolors. For larger pictures, you'll need a studio easel, like in the picture: an easel that's very solid and lets you work with ease for all sizes of paintings. Even though they are customarily in a vertical position, there are some types of easels that you can incline quite a bit.

The majority of easels that were designed for oil painting can also serve for watercolor painting. However, some special models, like table easels, are especially made for watercolor painters, since most of them prefer to paint with their paper flat on an easel.

THE WORK TABLE

An ideal table for watercolor painting is one that's referred to as a drafting table; it raises and lowers and can be set at various angles. It also makes a good foundation for a folding easel. This is a good idea because tables that incline tend to be inconvenient since pencils and brushes roll off.

If your studio is spacious, you can have a couple of tables on which to have works in progress. Keep in mind that the tables have a way of becoming filled with objects and that it's easy to neglect the mess, leaving it all over the table. It's very important, then, to have shelves for books and accessories in the studio, keeping your tables free of clutter.

For watercolor artists, drawing boards are important tools, in the studio as well as for working on easels outdoors. The drawing boards for watercolor should be light and have a smooth surface.

A scissor file is a useful accessory. The artist can show loose sheets easily, without having to pull and damage other watercolors. The scissor file should be collapsible, so in a small studio, it does not take too much room.

RECEPTACLES AND ACCESSORIES

It's a good idea to have some cups and cans in which to store pencils and brushes. If possible the studio should have running water to wash brushes and to change water in the jars when necessary. Also helpful are thin wood drawing boards of different sizes upon which to place your paintings. Another important accessory is a collapsible file; this makes it easy to show your work.

PROTECTING THE PAPER

Whether your paper is painted or not it should always be kept flat. Wide studio cabinets with large drawers are ideal furniture to store your paper but they take a lot of space and are expensive. You can substitute vertical files that may be constructed of wood.

There are very few homes that are big enough to have room for a sales gallery. Your studio can do double duty, so you can show your paintings right in the same space where you created them.

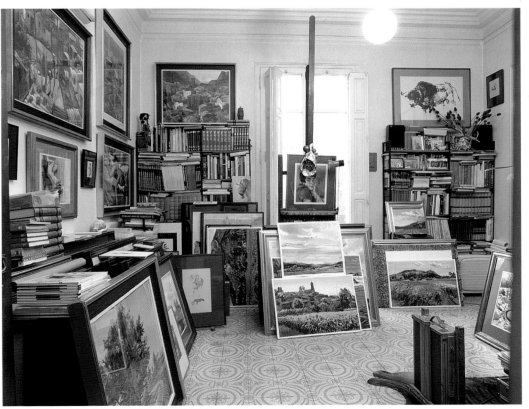

Your Outdoors Studio

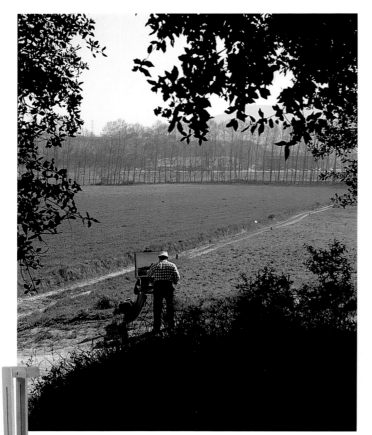

EQUIPMENT FOR PAINTING ON LOCATION
To paint watercolor landscapes on location, your materials should meet the following conditions: complete, manageable, solid. It should be complete in the sense that it includes enough to work with, manageable in that it can be carried easily, solid because working outdoors there are problems. Little accidents can crop up due to changes in temperatue and high winds.

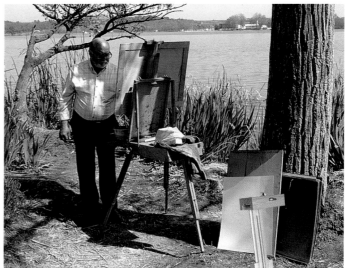

There are many models of portable easels. The simplest ones are very light and easy to set up and carry. However, this type of easel may be too unstable and not durable enough for some outdoor painters.

EASEL
Portable easels used by oil painters are equally adequate for watercolor painting. The most practical and solid of all the models is the sketch box-easel (also known as the French easel) that folds up into a box the size of a paint set. In the drawer, you carry brushes, colors, sponge, pencils and other materials. The canvas or board support folds into the box as well as the legs of the easel.

Working outside requires certain convenience and organization. The sketch box-easel has suitable characteristics: it can be carried in a small case, protecting your materials and, when set up, it provides a solid support for all types of work and in any weather condition.

The simplest portable easels are not very safe from high winds. Moreover, you can't carry materials in them, forcing you to have an additional box to carry colors, brushes and other tools.

Here is a picture of a portable easel. The large drawer can support your palette, and store rags, sponge and the rest of your tools.

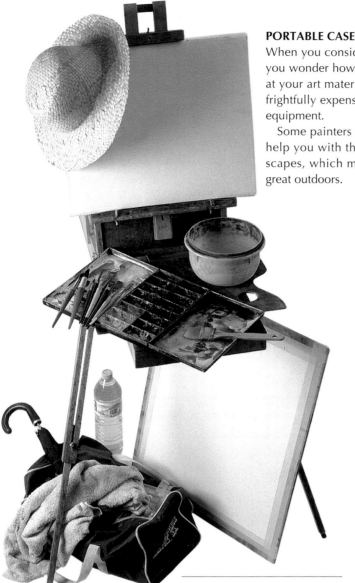

PORTABLE CASE

When you consider all the materials you have to have with you on a painting trip, you wonder how you will carry it all. There are extra large boxes that you can find at your art material dealer that can solve this problem. Of course, these boxes are frightfully expensive, which should make you think of other ways to cart all of this equipment.

Some painters make their own boxes. I'm sure the lumber yard in your area can help you with this project. Anyway, the fact remains: if you want to paint landscapes, which means painting from nature, it means carrying your studio to the great outdoors.

Last but not least is an average-sized umbrella. There are days when you will be caught out in the rain. On clear days, the umbrella, attached to your easel, will protect you from the heat of the sun.

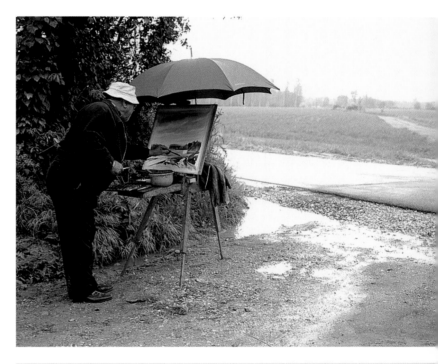

In the photo above we see the elements which make up sensible materials for outdoor watercolor painting: the sketch box-easel, brushes, pencils, a tote bag, and a hat to protect the painter from the sun.

CHAIRS FOR OUTDOOR PAINTING

Watercolorists who don't like to paint standing should bring along a folding chair. There's an assortment of small folding chairs and ones the size of a walking stick that are surprisingly comfortable. Most artists have used small studio stools which, despite having no backs, can be comfortable. The artist has to take into consideration the inconvenience of carrying any one of these chairs and wonder whether it's worth the trouble.

DRAWING BOARD

As I've said earlier, the drawing board is indispensable. It offers a solid base upon which to paint. It can substitute for a medium sized portfolio or folder and, moreover, protects the sheets of paper. The size of your paper should never be larger than that of the board.

If you choose a place that's convenient to your car, you don't have to leave any of your materials behind.

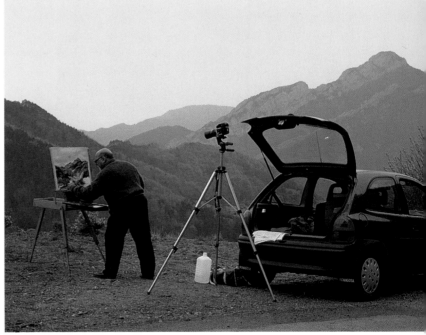

STEP-BY-STEP

Painting a Monochromatic Watercolor

T he first step-by-step in this book is elementary: working with one color. For this watercolor, I have chosen a simple landscape without any complex forms and tones. As you can see, the landscape is one of a manicured farmland with a horizon of mountains in the distance. There are also some trees whose foliage cuts against the sky on a very clear but gray day. Between the two extreme values of light and dark (the farmland and the sky) are distributed intermediate values. These are the planes of the farmland in the foreground, the branches of the trees and the rest of the hills that rise over the horizon.

■ **HELPFUL HINT:**

We don't really need a palette when painting with a single color. It's important to keep in mind that this color should always be dark. You will get clear values by saturating the brush with a lot of water and then using a little, checking as you go by testing the color in the margin of the paper on which you're working.

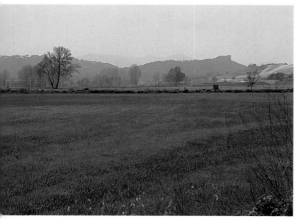

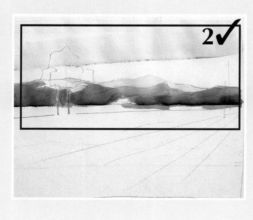

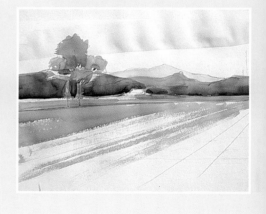

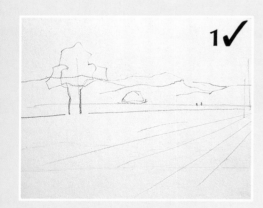

■ **THE PROCEDURE**

It is always difficult to learn to paint through the means of the written word. In areas where there aren't any teachers, and also where so many of us want our knowledge of the craft refreshed, we are certainly grateful for this kind of instruction. Of course, it all seems to go slower than it really is. This step-by-step demonstration went very fast; I was done in less than ten minutes. Much more than that isn't necessary for a painting of this type. A watercolor like this one is merely a study of the values of light. Other considerations, such as great amounts of details, can be forgotten for this particular project.

STEP-BY-STEP

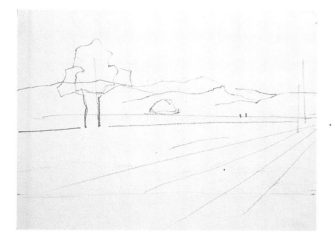 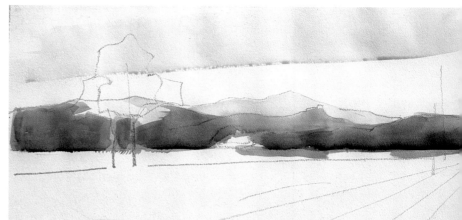

1 Here is the drawing in pencil. We can hardly call it a drawing because it is so simple, merely indications as guides for the watercolor that will be painted. The drawing, whether simple or complicated, is always linear when you paint a watercolor — never halftone shading. The lines of this composition are enough to guide me to paint the mountains and the trees, which represent the focal point.

2 The first stroke is the sky, in a tone that is close to the same value of the paper. Applying the color with a great amount of water, I paint the boundary of the mountains. I created this tone, in a way, by squeezing the color out of the brush.

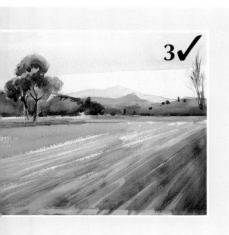

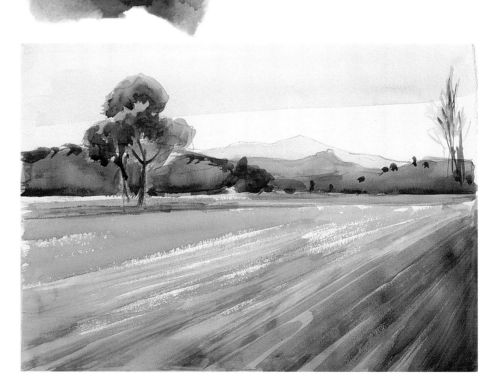

3 The painting is finished. We can see how the details are a simple balance of values. Some small points are almost black (in the hills in the background). They help to maintain this area as the focal point.

STEP-BY-STEP

Watercolor in Sepia

The photo below, as you can see, is in full color. You have to admit that the scene is on the ordinary side. I felt that it could be improved if painted in values of one color, and I chose Sepia as the color I would use.

In the previous landscape, we resolved distance through the play of values and perspective. In this case, the contrast of values is very clear and is determined by the whiteness of the building and the darkness of the vegetation. Between these two extreme values there are subtle gradations that are more complicated than anything we ran into in the previous step-by-step. Here, successive illumination and darkening were required. For this painting, I chose tones of Sepia which correspond more to natural dark earth tones.

■ *THE PROCEDURE*

I began by marking a contrast between one dark and one bright; to do this helps me because it proportions the general tone of the painting. Between these two great contrasts I have gone looking for in-between values, always respecting the white of the house and attending to the darkness of the trees. At this point, I'd like to direct your attention to the finished painting in which you will see some drips at the bottom of the piece. I did nothing to correct this, feeling that these drips do not hurt the final result.

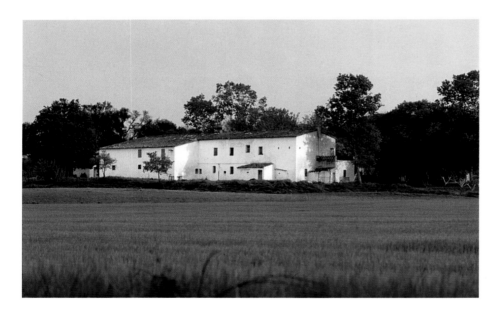

■ *HELPFUL HINT:*

Here is a monochromatic watercolor that was painted with one brush. If I had used a fine round brush, I could have never achieved the paint coverage. I got my strokes more successfully through the use of a chisel-edged brush, a brush that sign painters customarily use. It is called a single stroke brush.

STEP-BY-STEP

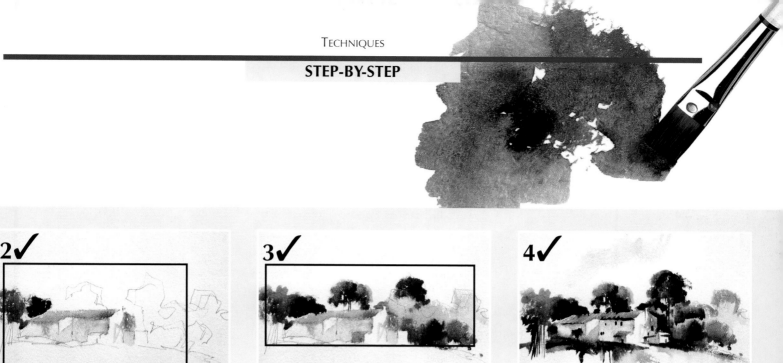

1 In this painting, the drawing is done with a line that is continuous; it encircles the contours of the composition. The watercolor painting is done with strokes of tones; it is not necessary to carry it further. The work would be filled with useless details. The line carries the design well, and it, too, is as far as I want to draw any detail. In effect, while the procedure looks easy it is indeed difficult.

2 The fundamental contrast between the clearest values (the white of the paper) that can be seen in the walls of the building, and the darkest (the grouping of trees) that appears behind the house, is easily established. I have worked the house on damp paper which I wet with clear water before painting. Using color in this way, the lightest values are easy to get.

STEP-BY-STEP

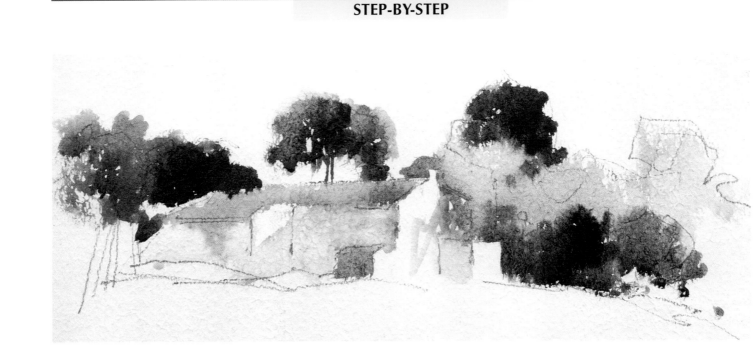

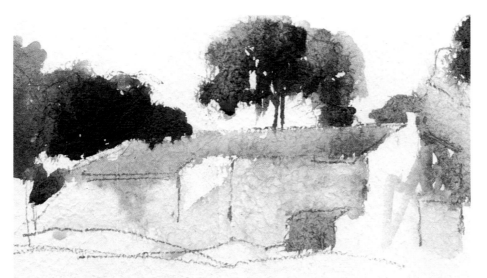

3 The step-by-step begins to substantiate the general distribution of the values. This is possibly the most important step. The value distribution makes the composition come together and gives importance to a simple scene. It will be only a question of fine tuning and detailing to finish the painting. We can see in the detail (above) that the walls of the house, while in shadow, still remain the lightest value in the piece.

STEP-BY-STEP

4 The clarity of the house has now been established and has been shaded by the darkness of the building's foundation. I have worked with the tip of the brush to define the trunks, outlines of the treetops, windows and roof, paying careful attention to all the values. The strokes that mark the clouds in the sky and the foreground has been applied with plenty of water to keep those areas the very lightest value, almost as light as the white of the paper.

STEP-BY-STEP

A Three-Color Landscape

I usually treat watercolor sketches as fast exercises before I go on to rendering large, important watercolors. The rapid sketches can themselves be more interesting than larger pieces that use the entire palette of colors. In the step-by-step on these pages we are going to see from the technical point of view that a watercolor with limited colors can be artistically complex. In fact, this won't be a monochromatic watercolor; it will incorporate three colors — Carmine, Ultramarine Blue and Lemon Yellow. Moreover, while the blue dominates, we can certainly find in this watercolor other colors along with their admixtures. Here is a problem of looking for values and colors: colors of similar value (darkness) and values of distinct colors.

■ *THE PROCEDURE*

This is an exceptional theme in landscape painting, because it isn't normally the location or the time of day which landscape artists are in the habit of working. In any case, the illumination requires a watercolor treatment based on transitions between distinct values. What is radically different is the backlighting that eliminates color almost completely and thus sets up the strong play of *chiaroscuro*. The work begins farthest back and comes forward toward the foreground as the piece progresses.

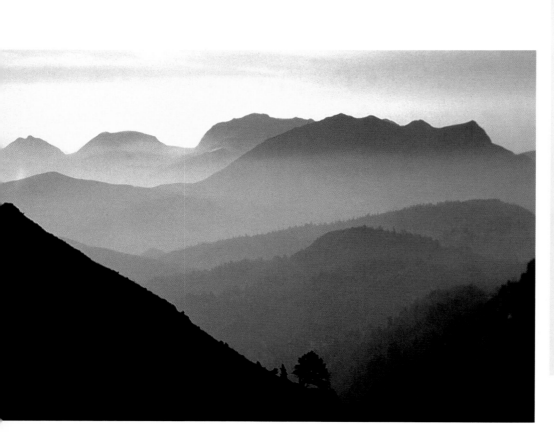

STEP-BY-STEP

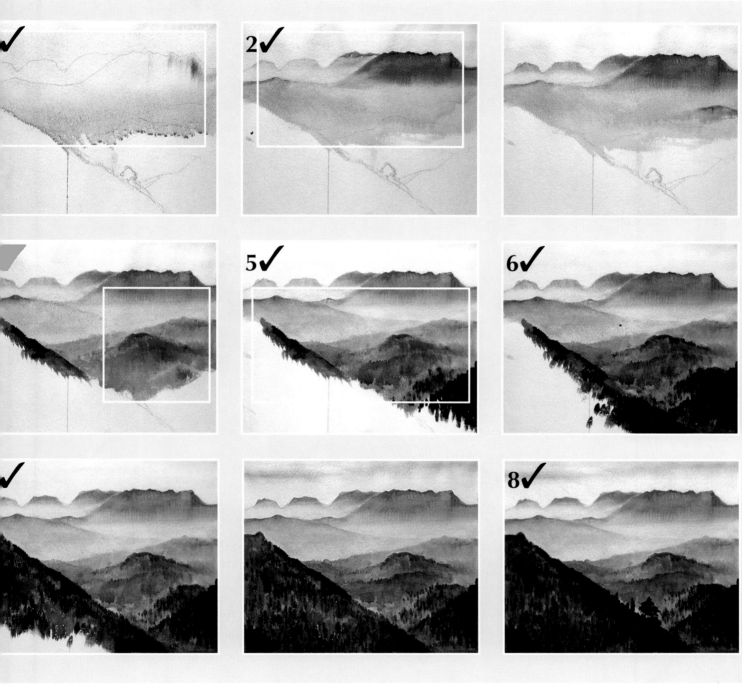

■ *HELPFUL HINT:*

The capacity to unfold many tones through a single color is due to the use of a lot of water, making it ideal for monochromatic painting. This picture includes more than one tone and more than one technique. Here we have the solutions, transparencies and saturations of color; with the work of the dry brush, the absorbencies, the washes, and so on.

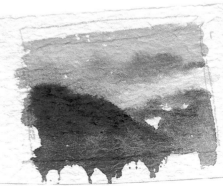

STEP-BY-STEP

1 Since this landscape does not contain details, the pencil drawing is extremely simple; it consists of a succession of colors and blended tones. Most important in the composition of this watercolor is its progression from the pencil drawing.

2 While much of the water has been practically absorbed by the paper, it is still very damp. Now it's a good idea to begin to paint the distant mountains. For this, I use pure Ultramarine Blue diluted with water. I begin to paint the top of the mountains, pulling color down to get a more diluted blue as it hits the damp paper.

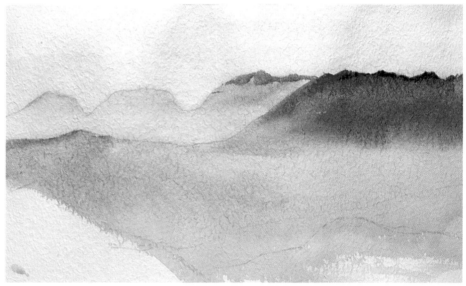

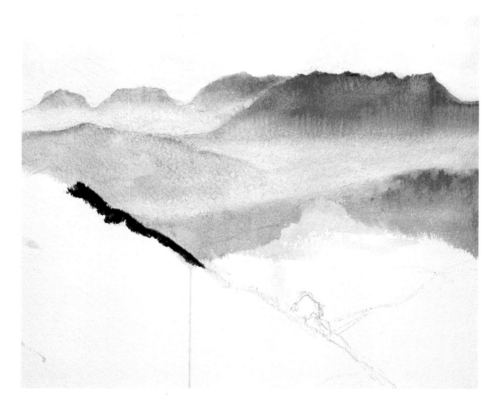

3 I continue here with the same process: applying blue and letting it become diluted by the dampness of the paper. Between the successive layers of mountains I left bands of pale Yellow Ochre which I applied previously in Step 1. This color is valuable to me for fog or mist, creating that dense atmosphere of clouds that surrounds the crests of the mountains. In the closest foreground of the composition, I have added some Carmine to the blue color.

STEP-BY-STEP

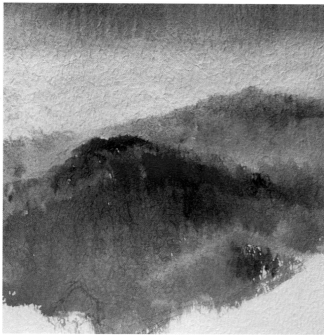

4 The central mountain has been rendered. As you can see, its color is more intense than the simple pure blue of the other mountains. It is a dark purple which was made of a mixture of blue and Carmine with a touch of Lemon Yellow. The procedure that I have followed has resulted in working with a light enough watercolor to later intensify different tones through the introduction of Carmine. As in the rest of the mountains, the peaks are a darker color.

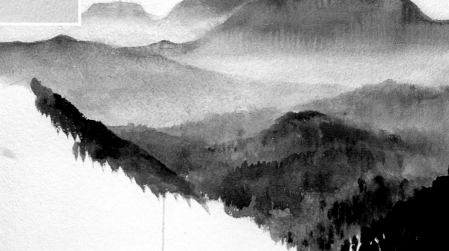

5 Now, working with a color that is dominated by Carmine, I see the lower part of the central mountain. I intend to paint this step with a dark color of the slopes to the right. I work alsmost on completely dry paper, because I want the paint strokes to be more precise, individualized and controlled.

6 It's possible to understand that this watercolor painting is about a limited amount of colors as opposed to a watercolor that uses the entire palette. Its appearance comes from a heavily dominant purple-blue tone, but it is not only a work of values or intensities of light and shadow but also of color. We can see in the foreground the contrasts with black.

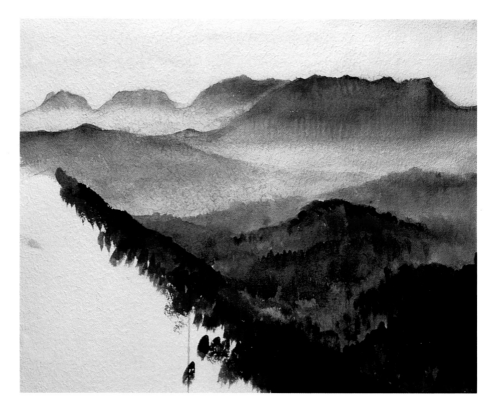

STEP-BY-STEP

7 The plate at left, which served as my palette for this painting, displays the limited colors that I used. While the yellow looks bright on the "palette," it is hard at this point to pick out the areas where I used this color; it's in the valley between the slopes, in a very pale application. The overall coloration is blue, but because of the introduction of the intense Carmine, a definite violet color now dominates this painting. As for procedure, from this point on, I am working with color that I have painted over dry areas.

STEP-BY-STEP

8 After some significant details have been completed, the painting is finished. In the first place, the mountain on the right has been refined. Now, it does much to add the vaporous atmosphere that I have created with the three colors. Furthermore, I have included some silhouettes of isolated trees. These simple details are painted with thoughts toward the proportion of the entire piece.

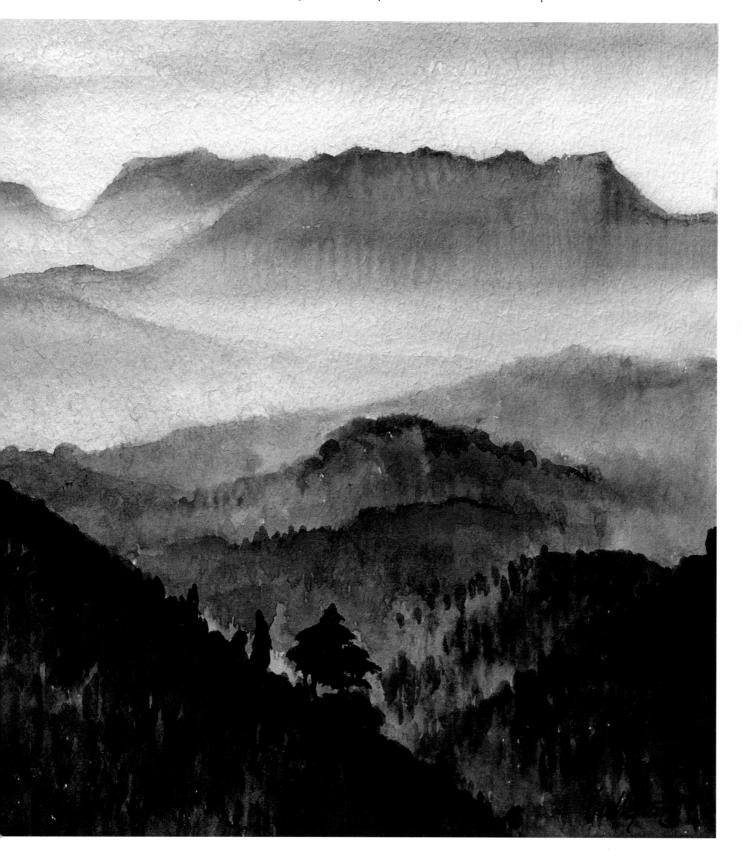

LANDSCAPE COMPOSITION

Planes and Masses

On the right, we see a watercolor by our resident artist, Vicenc B. Ballestar. To its left is a diagram that is stripped of all details and shows only the masses of the painting. This is a good way for you to evaluate paintings that you admire and also to diagnose those of your own.

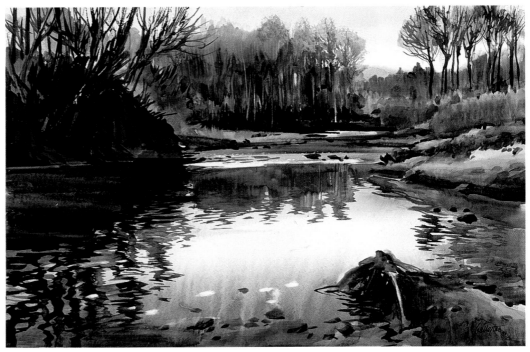

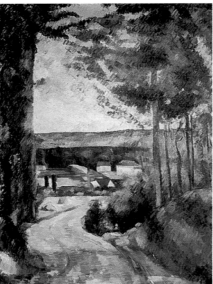

Paul Cezanne, The Road to L'Estaque. Rijksmuseum Kroller-Muller, Otterlo. You can easily see the obvious masses and planes in this impressionist's composition.

COMPOSITION THROUGH PLANES

The composition of landscape through planes is based on a linear vision of the theme. The artist makes an abstraction of the lights and shadows and of the individual elements of the theme. The fundamental element of the composition through planes should be the line of the horizon which is the element that distinguishes the basic planes of sky and earth.

In the composition by planes the artist projects a series of simple rectangles and curves that enclose the planes of the landscape: the foreground and the rest of the boundaries. There is always some element in the theme that suggests

these lines: the margin of a road, the limits of a field, the bank of a river, a road, etc. The lines of the composition can also be suggested by the relationship between distinct boundaries. So, for example, the slope of a mountain and the roofs of some nearby houses can be put into relation with the same diagonal line; a curve can unite the curve of a road and the tops of some trees.

The reason for this type of composition is in the simplification of variety in order to create a single, unified element. Through simple lines one can incorporate details with clarity, rather than reproducing them one by one independently.

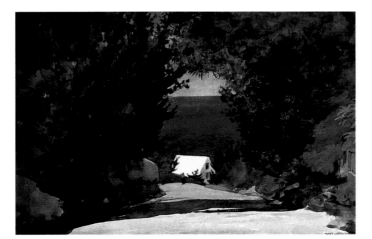

Winslow Homer, Road in Bermuda. The Brooklyn Museum, New York. In this watercolor we can locate the focal point and get a feel for the design of masses and planes.

COMPOSITION THROUGH MASSES

Another type of composition is based in the great masses of a landscape. These masses more than correspond to elements of rocks, trees, buildings as to great areas of light and shadow. Mass can also be a mass of sky in a landscape in which there is a strong contrast with the color of the earth. You can prove this by squinting when looking at the vista. You will lose the definition of details that you would ordinarily see with your eyes wide open.

Vincent van Gogh, Haystacks Near a Granary. Rijksmuseum Kroller-Muller, Otterlo. This landscape has been clearly designed to take advantage of the massive haystacks. They function as the principal focal points of the landscape.

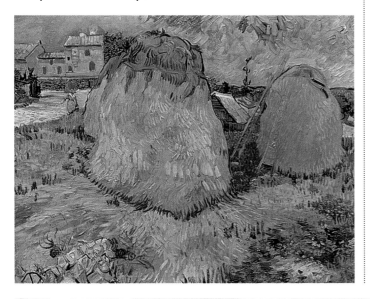

THE BALANCE OF THE COMPOSITION

To organize and balance the boundaries or the masses of a composition we ought to have in mind a series of factors: the size of the forms with respect to others, the distance that separates them and the distinct level of brightness or darkness that they have. All these factors are conditional to the others. An important element for its size (a large tree) can lose importance through its incorporation in a large shadowed zone, inside of which it is less emphasized. A small and distant element can become determined in the balance of

Hia Kouei, Pure Vision. Palace Collections, Taiwan. The Chinese countryside should always be recorded in a balance of full and empty, as seen by the focal area of rock and vacant spaces to the left.

the composition by its very dark color, or very bright or very alive. The balance of the composition consists in compensating the arrangement of the great masses with elements emphasized by their form and color. Balance does not want to stay static. At times it is good to throw things off balance to create interest and introduce life into the composition.

The sketch that is shown above illustrates the simplicity of the composition of the painting that's reproduced at left. Squint at the painting. See how easy it is to discern the abstract-like diagram.

The Focal Point

CENTERING THE INTEREST

Arriving at the focal point is not distinctive to watercolor. All painters, no matter the medium they paint with, look for a center of interest, and that point of view establishes the focal point. It's amusing to note that while your interest is centered, the artist should never locate it in the center of the painting. The focal point should be located in the upper or lower thirds of the painting, either at the left or the right. Again—never in the center.

In composing a landscape, the artist first selects the focal point of the vista that stretches before him, and then, through the use of a concentric circle from that point, he either draws it on a sketch pad, or fixes it in his mind. From out of the panorama of the landscape, the focal point can be established. This is a simple way of picking out a composition from among all of the landscape that looms up before you.

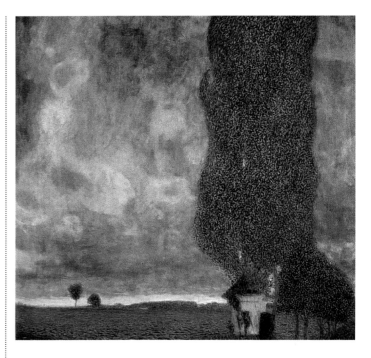

Gustav Klimt, The Great Alamo. Private collection. In this painting, there is no question about where Klimt located the focal point.

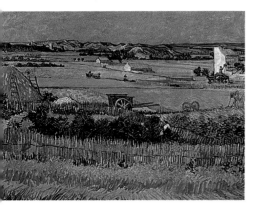

Vincent van Gogh, Harvest Landscape. Rijkmuseum Vincent van Gogh, Amsterdam. The focal point in this landscape — the wagon — is slightly off center.

A WAY TO COMPOSE YOUR PICTURE

Some artists use a cardboard mount to help them compose their landscapes. It consists of two right angles of black cardboard which the artist manipulates to frame the landscape he sees. Within the two right angles, which, when put together, create a rectangle, a very nice landscape can be composed. The artist then draws on his paper the sketch he has seen through his finder. Few professional painters use this system, since they rely on their sixth sense, an instinct that they have for locating focal points.

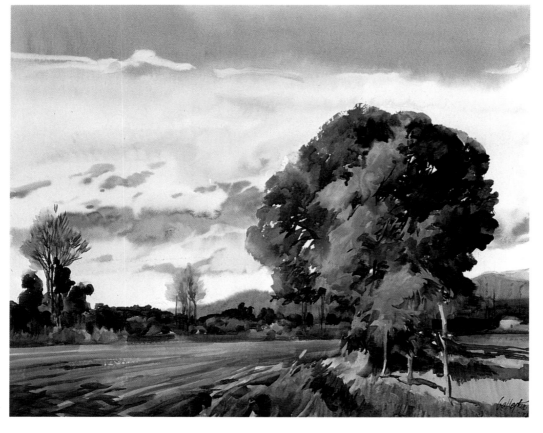

The focal point of this work by Ballestar is obviously the cluster of trees at right. The viewer's attention is drawn immediately to that important portion of the painting.

INTERPRETING THE THEME WITH THE FOCAL POINT

The artist and great teacher, Robert Henri (1865-1929), said, "A good composition is a clever feat of organization. The eye should not be led to where there is nothing to see." The spot to where the eye should be led is the focal point. The focal point can be arrived at through exaggeration, simplification or a combination of the two. The focal point should never be an accidental selection; a painter stages it in much the same way that a director designs where he wants his actors to stand on stage. The focal point can be established through the use of color and design of an object or area.

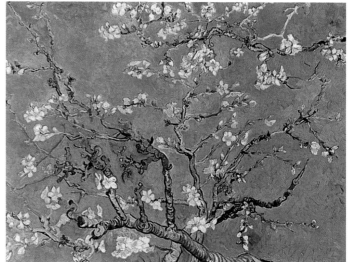

In Ballestar's landscape, shown above, the focal point appears to be in the center but it is not. The artist used warm colors to set his focal point apart from its predominantly cool surroundings.

Paul Cezanne, The Great Pine. Museum of Art of San Paulo. This picture, that features a single tree, directs the viewer to center attention on one portion of the foliage at the top.

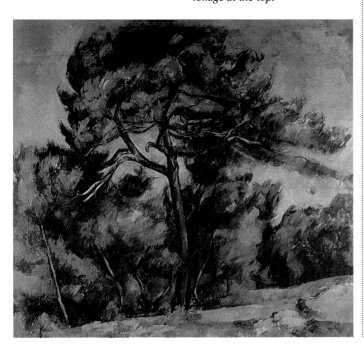

Vincent van Gogh, Branches of a Peach Tree in Flower. Rijksmuseum, Amsterdam. In many of van Gogh's paintings, the influence of Japanese art is obvious. This particular painting, while decorative and attractive, does not seem to contain any definite focal point.

THE GRID

Departing for a moment, from the focal point, I direct you to an important facet of sketching in relation to painting. While some watercolorists enjoy starting "from scratch," which entails sketching directly on their sheets of watercolor paper, other artists, more cautious about their painting, choose to make scores of black and white or color sketches in preparation for the full sheet watercolor painting. Then, back in their studios, they transfer the sketch they favor to their sheet of paper.

One of the procedures for transferring is merely to copy, free hand, the scene from the sketch. However, for those who are more interested in a precise interpretation of the sketch, the grid system is used. This is drawing a grid over the sketch and then drawing another grid, larger and in proportion to the smaller squares of the sketch, onto the paper. The artist then duplicates everything he sees in each square of the sketch onto each corresponding square on the watercolor paper. As you can imagine, because of the mechanical nature of the process, any spontaneous look that the artist may have captured in the sketch has to suffer when it is laborously transferred to the larger paper.

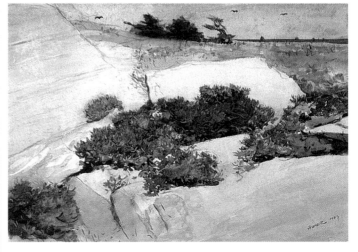

Winslow Homer, Cliff in Maine. The Brooklyn Museum, New York. Again, we have a focal point which is only slightly off center, which is perfectly all right.

Contrast of Forms

UNITY AND VARIETY

Within the framework of a painting's design, there are two elements that contribute greatly to its success: unity and variety. While on the surface they seem to be contradictory terms, they actually complement each other. Unity makes all things fit and are sensibly suitable to each element in the composition. Variety makes sure that there is no obvious feeling of boring repetition of shapes, spaces, tones and colors.

Hermanos Limbourg, February. Conde Museum, Chantilly. In this work (shown below) the artist has given each object a distinct form that is independent within the entire composition.

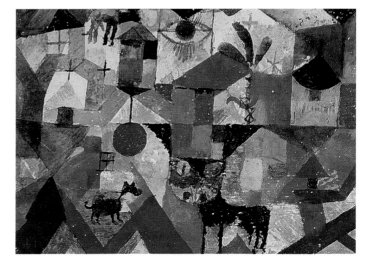

ACHIEVING VARIETY THAT UNIFIES

The matter of unifying areas while still maintaining variety is prevalent in landscape painting. Take, for example, a mountainous range that you choose to paint. While the mountains present forms and shapes that are the same and may border on the monotonous, an experienced painter can alter certain shapes to introduce variety. Of course, this means that an amount of editing the scene has to take place. However, in most cases you will find that nature is her own successful editor, leaving infinitesimal differences for the artist's benefit. Individualizing

Paul Klee, Zoo. Yale University Art Gallery, New Haven. In spite of the continuous contrast of forms in this watercolor the artist has maintained a certain regularity which results in repeating a zigzag pattern in the length and width of the whole composition.

each rocky fragment with its particular anatomy, gives the painting, with its combination of independent parts, that extra touch. On the other hand, if all elements of the composition are represented equally, the artist will lose the character that's peculiar to the landscape.

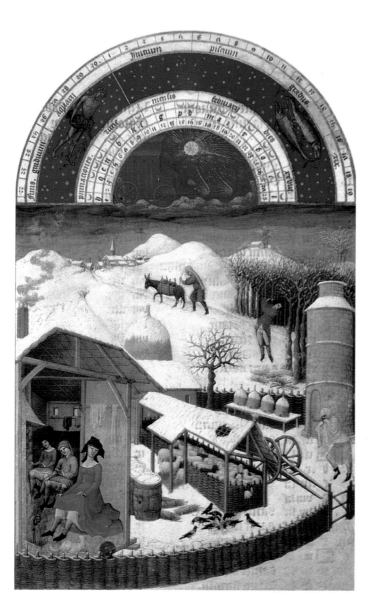

CONTRAST OF DRAWING, COLOR AND SHAPE

Drawing, color and shape are the factors on which differences between landscape forms depend. Two trees of a very similar shape can contrast by their color, such as one being illuminated and the other being in shadow. Two objects, such as houses on a hill, may have the same color but can be different and contrasting in their shapes. In a landscape of flat country, the contrasts can come from the variations in the color of the land.

In general, one can say that the painter, in his search for unity and variety, should intensify or soften the drawing, the color and the shape of the elements. Each one of these factors is independent of the other and making only one of them different should result in sufficient contrasts.

Edward Seago, Wooded Bank.
Private collection. The silhouette
of this tree is enhanced against
the fog.

John Singer Sargent, Palms,
Florida. The Metropolitan
Museum of Art, New York.
In this watercolor, the shapes
are distributed throughout the
entire surface of the paper.
The result is a texture of lines,
of light and of shadow that
suggests the lush vegetation
of the tropical forest.

CONTRASTS AND RHYTHM

Creating contrasts in a landscape produces a visual rhythm that attracts the attention and interest of the artist and the viewer. Alternating rectangles and curves, bright and dark tones, warm and cool colors all help to maintain a rhythmical order. And the rhythm, as we know, can be repetitive and monotonous from too much unity, or fragmented and jarring from too much variety. The correct alternation, as just mentioned, is the pleasure we get from the rhythm.

Ferdinand Hodler, Rocks in the
Forest. Hodler was a painter of
great precision in the representa-
tion of shapes. Each of the stones
has its own characteristic and
can be perfectly aligned with the
others. This is a fine example of
the use of variety within unity.
The clarity of the whole is, we
can almost say, superior to reality.

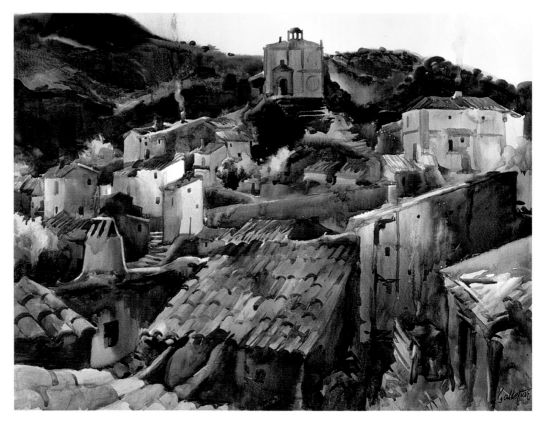

The direction of the houses in this
painting by Ballestar (at right), is
clearly ascending. It flows with a
rhythm of size: the small house
with the height of the church
above the hills. Variety and unity
here are balanced perfectly.
Without them, none of the factors
will dominate over the others.

Perspective

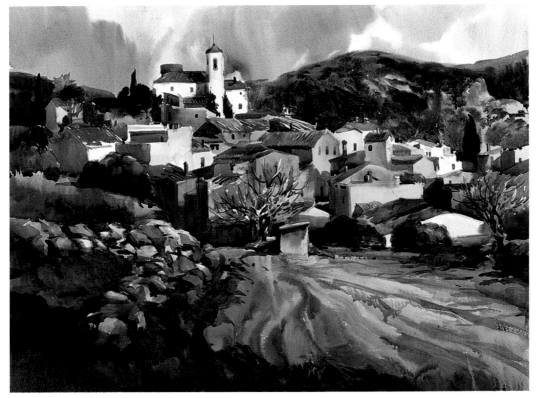

The orderly landscape (at left) uses conventional perspective. The eye level (or horizon line) is situated right in the middle, from top to bottom, and a bit off center from left to right.

LINEAR PERSPECTIVE

In linear perspective you always establish the size of that which is nearest to you and then relate it to the size of everything else that is farther away from it. A tree in the foreground, for example, can be established in a size that's right for your paper. Then, everything else in the composition, seen from the vantage point of the tree, is sized in a height that should be compared to the size of the tree to make it look like it's in the distance. This principle is seen so sharply when looking at railroad tracks that finally join at the horizon. Trees or telephone poles alongside the tracks seemingly get smaller as they go off into the distance. We know, however, that all of the telephone poles are, in reality, the same size.

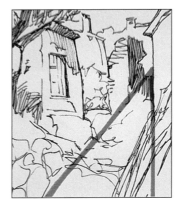

In this work, the vanishing point is located nearly outside the painting: the horizon line is very elevated and the sky doesn't appear. The place from which the artist painted the landscape is a very straight street. You can see in the diagram the vanishing point which all roads lead to. The dimension that a composition such as this creates is extremely dramatic.

AERIAL PERSPECTIVE

Since the tones and colors of things in the distance can't be the same tones and colors as those same things in the foreground, the artist uses principles of aerial perspective to get this effect of distance. In aerial

perspective, the color of things and the tone are diminished and lightened respectively as they go farther from your point of view. This is the way the artist compensates for the change in distance from his point of view. To sum up: linear perspective deals with the relative size of objects, diminishing the size of these things as they go deeper into the distance; aerial perspective deals with the intensity of tone and color which get lighter as they go deeper into the background.

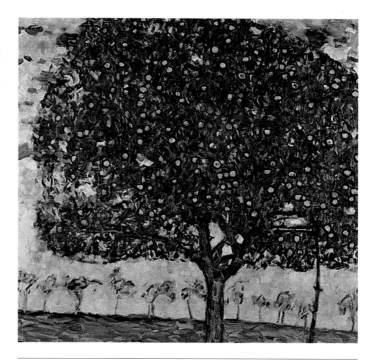

Gustav Klimt, The Apple Tree. Oesterreichische Gallery, Vienna. There is no perspective in this landscape since the background objects are on the same plane.

Edward Hopper, Road. This apparently simple painting omits perspective. Everything is at eye level which eliminates any need for a vanishing point.

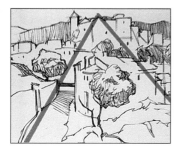

THE FLAT DRAWING

A flat drawing is the elements of the landscape without the embellishment of tone, color or perspective, either linear or aerial. Drawings of this type, while basic in their linear representations, are by no means simple to do. These contour drawings function as sketches to be enlarged and transferred to watercolor paper to then be rendered with the full execution of watercolor paints.

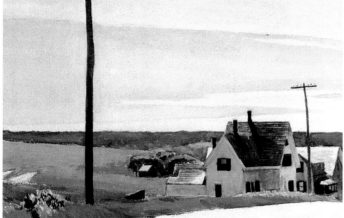

Unlike the other two paintings on this page, Ballestar's landscape makes use of perspective to give the effect of viewing from below. The vanishing point is located at the top of the church, and the lines of the lower part of the composition are directed toward it. The focus of the landscape has not been forced, it is placed simply, choosing a theme that's situated on the slope of a mountain. The buildings rise and are constructed one over the other toward the horizon.

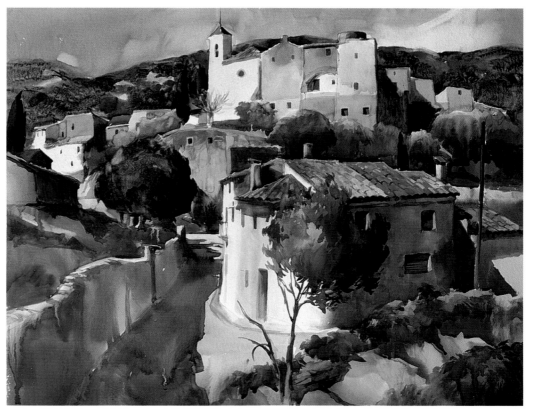

Creating Depth with Tone & Color

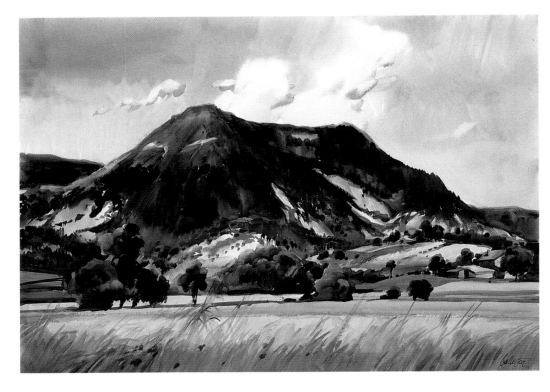

Jacques Fouquieres, Stream in the Woods. The Louvre, Paris. This watercolor (shown below at left) might remind you of a scene on the tapestries of the Flemish genius, Peter Paul Rubens. Nevertheless, it is a landscape in its own right. Its subtle graduation of the tones creates space and atmosphere.

GRADUATION OF TONES

As recently mentioned in the chapter that deals with aerial perspective, a contrast in tones and colors will create distance between elements in a painting. All representational landscape painters have to know this. It's the painter's way to insert dimension into the painting by showing that trees in the background, for example, can't possibly be painted with the same intensive colors and tones as those that appear in the foreground. While landscape painters working in all painting media do this, it's easier in the medium of watercolor, which uses only water to wash the tones to softer, lighter tones and to reduce a color's brilliance.

DISTANCES AND TONES

Distances in landscape can be expressed through contrast of tones, that is to say, through the contrast of bright tones and dark tones. Outstanding elements — trees, rocks, mountaintops — painted in a dark tone will overshadow a bright background. Due to the contrast of tones, this brighter background will be seen as more distanced.

Landscape artists know that a bright form standing out against a dark background — a contrast of tones—will be able to give them the effect of something in front or behind of another thing.

Gustav Klimt, Fruit Trees. Private collection. The pure color shows that the landscape deepens toward the background; the sizes of the trunks are the only indications of distance.

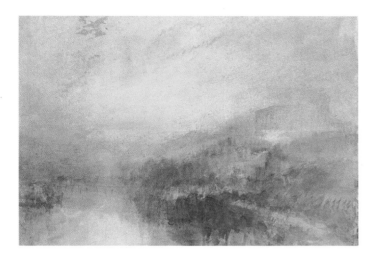

J.M.W. Turner, Valhalla, Regensburg Over the Danube. Clore Gallery, London. As with many other watercolors by Turner, this landscape expresses distances through the diminishing of color and its contrast.

DISTANCES THROUGH COLOR

Color promotes the sensation of space and distance in a way that's totally independent of perspective and the graduation of tones. This happens through the use of cold and hot colors. The subjective nature of color makes us see warm colors as closer to us than cold colors. To emphasize the foregrounds, warm colors are used, like the oranges, reds and siennas. To distance areas, cold colors, like blues or violets, are put into play.

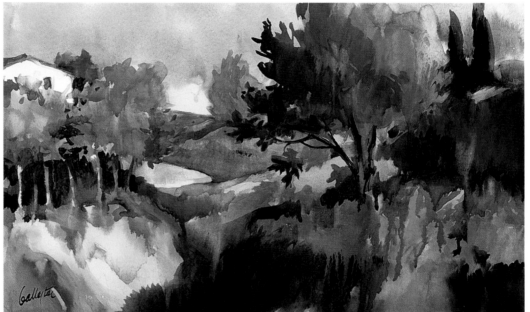

Ballestar, in this landscape at right, shows so well how he creates distance through the softening of color and tone as they move deeper into the distance.

ARTIST AS MAGICIAN

Artists can be likened to magicians in the way that they can create three-dimensions on a two-dimensional surface. Just think of it, out there in front of you is nature's landscape in all of its beauty and majesty. What a challenge for landscape painters! As we've been saying over the past few pages, artists have many devices at the ready to attempt their interpretation of nature's reality. A main one is the play of warm and cool colors. They use warm colors to make objects project or come forward; they use cool colors to make objects recede or go back. This is another perfectly reliable way for artists to pull off the caper, so to speak, to achieve dimension.

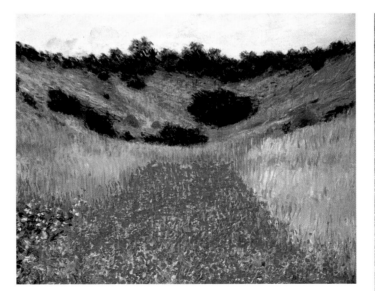

Claude Monet, Fields of Poppies near Giverny. Museum of Fine Arts, Boston. According to the impressionist methods, the landscape is organized through levels of color and ultimately by contrasts of tone and value.

Wang Mong, Houses in the Woods. Palace Collections, Taiwan. This is a painting of the 12th century and has the peculiarities of traditional landscape art of China. All the boundaries of the landscape occupy the same plane.

The Horizon Line

Ferdinand Hodler, The Breithorn. Kunstmuseum, Lucerne. The sensation of height is contrived by the low horizon. The large expanse of sky over the peaks of the mountain suggests its height.

AN ELEMENT OF COMPOSITION

The horizon line is important to the composition because it determines the width and extension of the landscape. The horizon line, in a general sense, can be a straight line (in the case of the sea) or it can describe mountainous irregularities of the background. It is always possible to determine a horizon line in any painted vista.

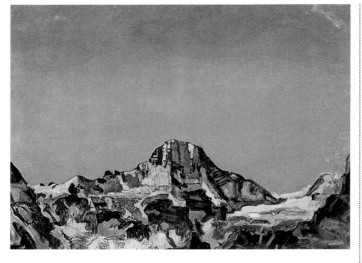

LOW HORIZON

The low horizon line implies a point of view that has been popularly called a worm's-eye view. The landscapes of The Netherlands specialized in low horizons due to the geographic characteristics of that predominantly below-sea level country. Dutch landscape painters used the low horizon to create pictorial space in contrast to scale and sizes of the elements of the landscape. In this type of work, the sky took on an importance that created the dramatic treatments that the Dutch landscape painters became famous for.

The low horizon of this landscape defines very distinct boundries and represents all that are separated by distance.

HIGH HORIZON

The high horizon, also called a bird's eye view, permits a landscape that occupies almost the entire surface of the paper. It corresponds to an elevated point, viewed from above looking down. Some artists elevate the point of view to go beyond the paper. The landscape then reaches color into the corners of the paper. Distances flatten themselves as in a tapestry and the work extends to the plane.

Gustav Klimt, After the Rain. Osterreichische Gallery, Vienna. This work is totally different from the landscape to its left. The horizon here is very high and almost the entire pictorial surface is taken up with the open meadow and the hens that appear there.

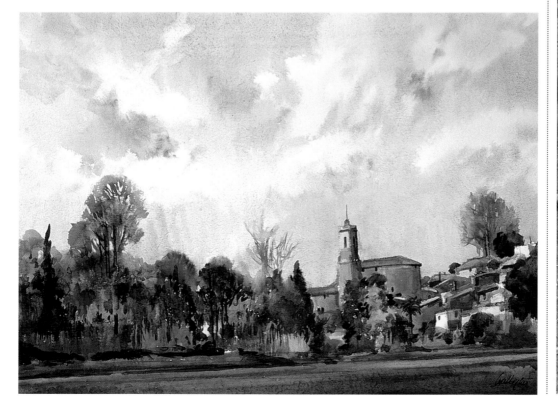

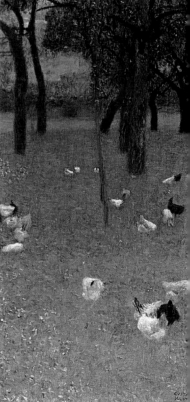

The elevated horizon is traditional in the mural type of painting, an art that brings the pictorial surface from above, down and from left to right without too many empty spaces.

The combined action of an elevated horizon and a clearly outlined perspective creates very interesting effects of realism. The painting, at the left, successfully produces a picture that describes perfectly the kind of day it represents.

Winslow Homer, Coast of the Bermudas. The Brooklyn Museum, New York. The presence of the sea here establishes the presence of the horizon. Homer has made use of this factor to compose a landscape of serenity.

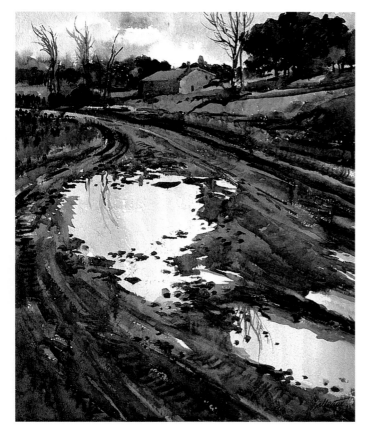

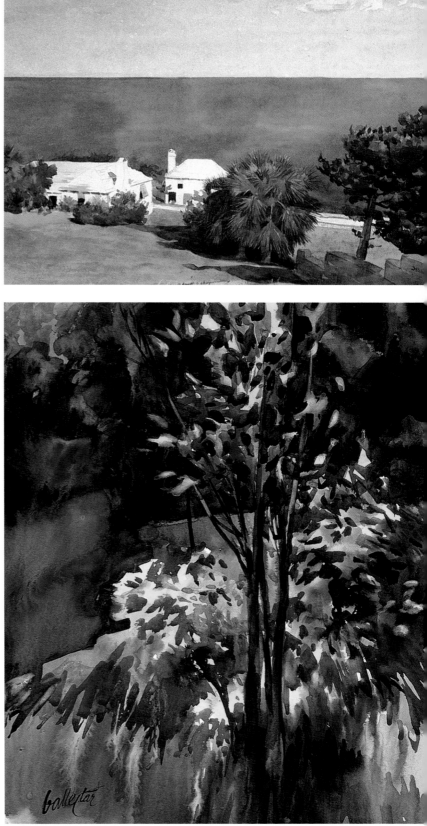

ODDITIES OF THE HORIZON

While there are definite rules that must apply and principles to be followed, we have to take into consideration another factor: the capriciousness of the artist. Here, the artist strays from the norm to put a special stamp on the picture. Where the horizon will be placed and what form the horizon will take is purely in the province of the painter who will do anything to make the exercise work. This idiosyncratic stance, we hasten to add, is not the luxury of only the modernist but resides as well in the creative machinations of the realist.

In this watercolor we don't miss a more explicit description of the environment, nor does it disturb us not to know where the horizon is situated. The major space problem is reduced to the contrast of the bush against the background.

STEP-BY-STEP

Painting a Colorful Meadow

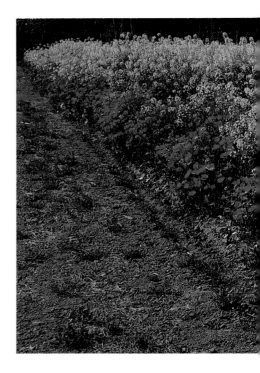

In this demonstration, I have chosen a field of yellow and red flowers growing in a cluster alongside a road. The composition, as well as the colors, was a simple one. In this painting, I used the wet surfaces to my advantage to create some accidents for spontaneous effects.

This demonstration concentrates on composing larger areas that dominate with blasts of color. Here, we will see how to use color brazenly and to come up with a picture that has all the elements of a more complicated composition. It's an exciting, audacious adventure in watercolor painting.

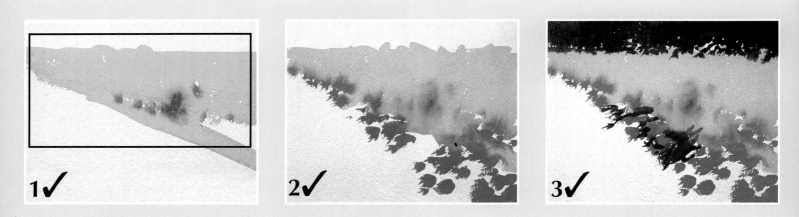

1 ✓ **2 ✓** **3 ✓**

■ *HELPFUL HINT:*

At times, the richness of the motif invites very complicated compositions. It is then when one should seek simplification. In this demonstration, we were anxious to do a simple sketch.

■ *THE PROCEDURE*

The rendition of this watercolor has followed a very direct procedure. The beauty of the colors has seduced me. I have reserved a band in the upper part to give some dimension to the meadow. I applied the colors with great spontaneity, working with the area, leaving to chance the blending and toning down of color.

STEP-BY-STEP

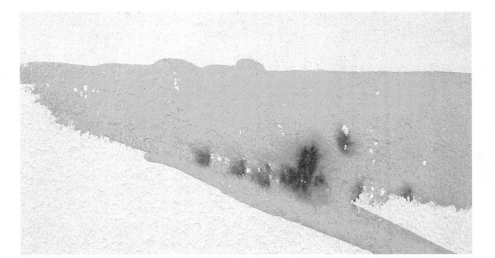

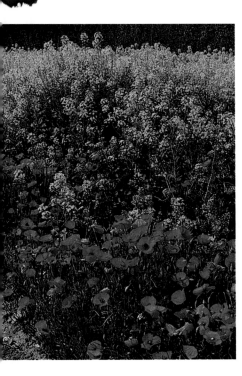

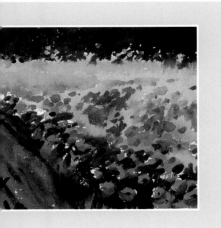

1 The entire composition of the demonstration falls into a triangular pattern. I haven't needed any pencil drawing simply because the color itself creates the basic composition, that is diagonal, and the rectangle above this area limits the colors. The color, I'm sure you're interested in knowing, is a Cadmium Yellow Medium sufficiently diluted in water to cover the area adequately.

2 Aware of the compulsion of the diagonal, I have applied strokes of Cadmium Red using an ox-hair #8 brush. Through the forms of the touches of color, it's easy to tell that I have worked fluidly with the brush on the paper. Also, you can see how some of these strokes of red (those on the right part) are blended in the still damp area of yellow which creates an orange color.

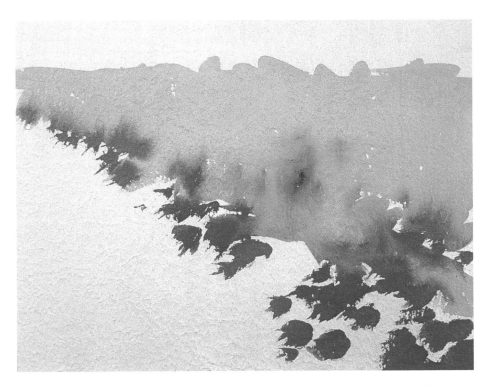

STEP-BY-STEP

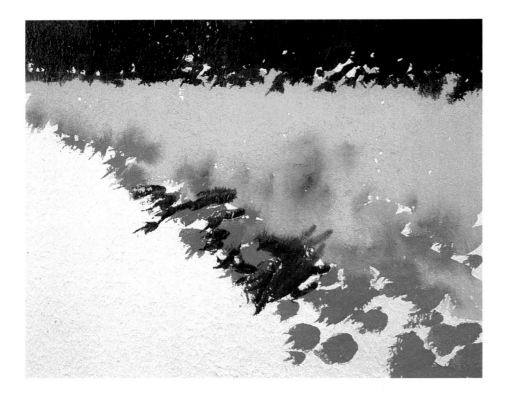

3 I framed the composition in the top section with a solid area of green (Permanent Green, to be exact). This provides a sensible border that makes it more like a representation of foliage. On the other hand, in the lower part of the strokes, I have saved small bits of yellow to create the impression of a mass of irregular wildflowers.

STEP-BY-STEP

4 The same green that I used in the background of the composition I also used to add to the groups of flowers; the green acts as a shadow and also, at the same time, as the color of the stems. The red strokes, which now perform as a border, become more convincing as representations of poppies. I have now painted the lower triangle on the left with Burnt Sienna. I took care to represent the boundary that surrounds this area with the meadow of flowers. The painting is finished. It's a simple demonstration in its conception, painted in a way that resulted in a watercolor of brilliant coloration.

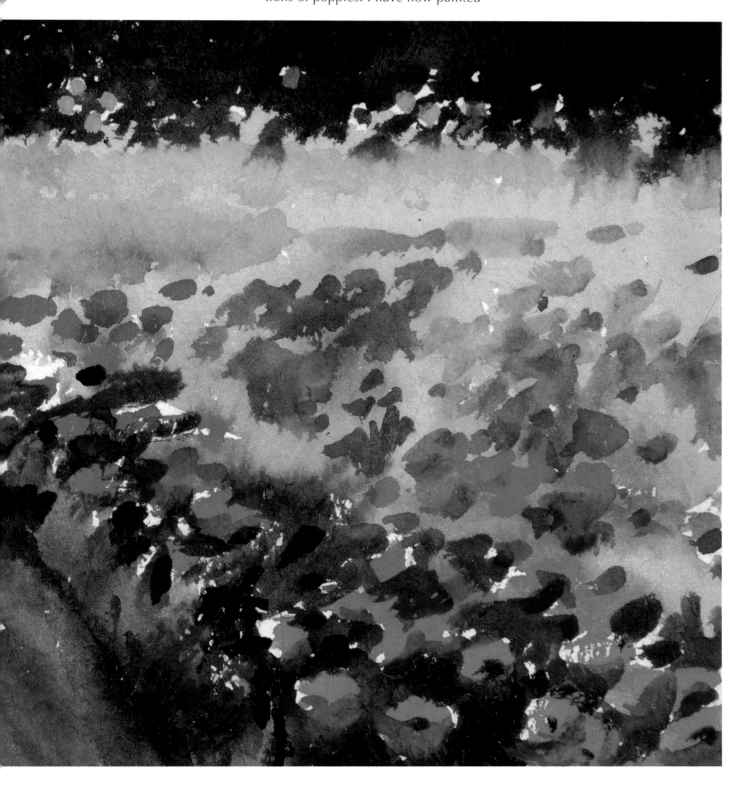

STEP-BY-STEP

Composing with Limited Color

The first thing we notice in the photograph (shown below) is that the cool color (blue) and the warm color (yellow) are equally divided in the composition. Since it would not be a good idea to repeat this boring design, I took care of that immediately; I devoted more space to the sky than to the yellow wheatfield. It's obvious that I made a wise choice for it was far easier to create interest with the clouds than in the monotonous field. I managed, however, to make the field more exciting than the material in the photo that I had to work with. You will also notice the paucity of color, which always makes it difficult for the painter. Why did I want to paint this scene? The complication of its plainness appealed to me.

■ THE PROCEDURE

In this watercolor, the correct situation of the forms was essential. The tops of the trees are set in the composition so that each of them can be seen in a place and distance with respect to the rest of the elements. The importance of the sky in this demonstration forced me to work with glazes. The tonal contrasts are everything in this step by step demonstration and it is important to get the correct tone along with the intensity.

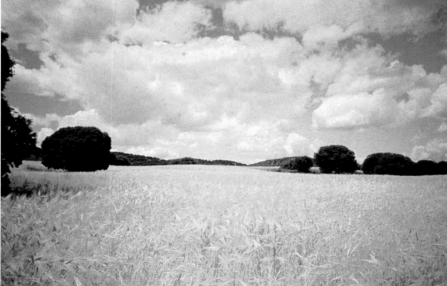

1 Over the glaze of yellow I drew with charcoal, sketching rapidly on the paper and placing each form in its place, paying attention to the elements of the landscape. The tops of the trees are indicated in more or less elliptical form.

STEP-BY-STEP

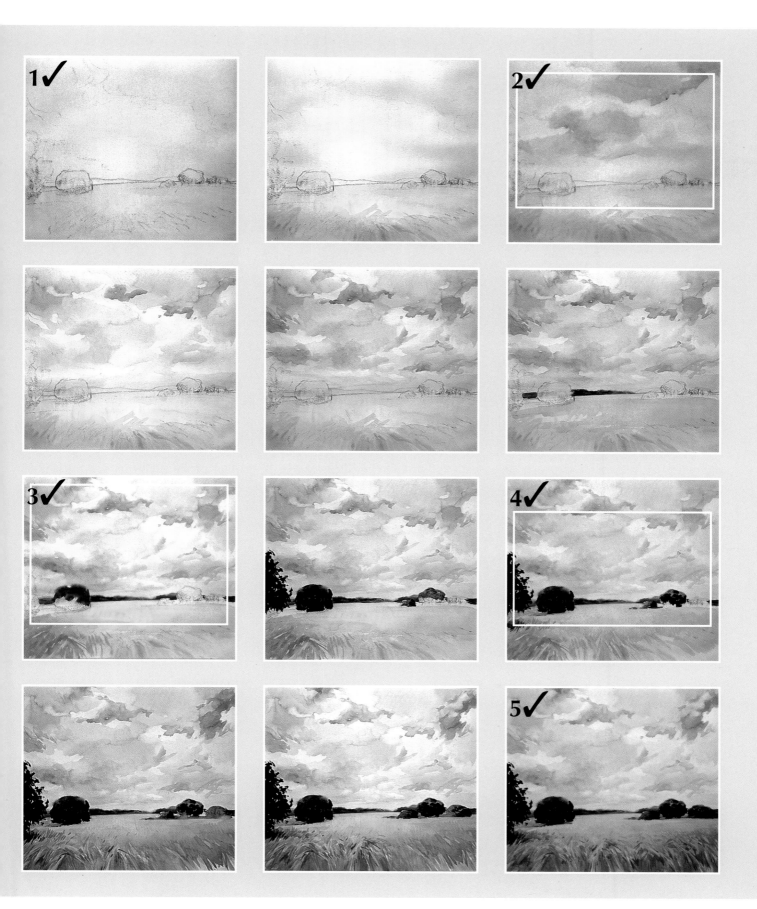

■ **_HELPFUL HINT:_**

It seems strange that I used charcoal to sketch in a watercolor. I wanted to get a clearer indication of the trees and I knew that
I could cover the charcoal with the deep green. After the area had dried, I dusted off any residue of charcoal on the paper.

STEP-BY-STEP

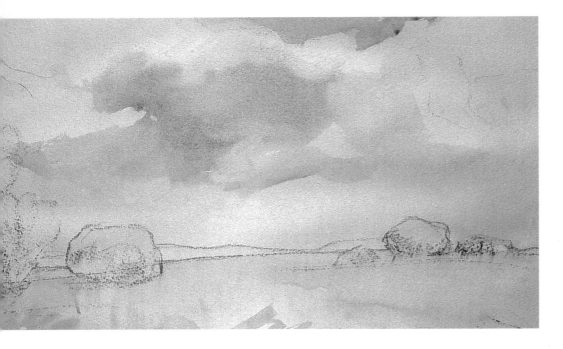

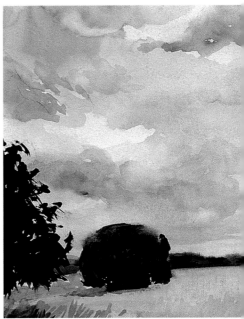

2 On the damp paper, I have begun to work as much with the sky as with the wheatfield. In the sky, I have extended some strokes of Ultramarine Blue with a little Burnt Sienna, very diluted, creating a bluish gray. Applying these strokes in distinct intensities and hoping that they are blending with the dampness of the paper, I give a spongy aspect to the sky to produce a series of transparencies and soft superimpositions. I have worked the wheatfield in a similar manner, applying strokes of Yellow Ochre mixed with a bright yellow, Cadmium Yellow Medium, in definite intensities, working over these strokes and softening the tone through strokes that come close to the center of the composition.

3 Everything comes together as I work almost simultaneously on the sky and the wheatfield. In the sky, blue fragments can be seen appearing through the gray masses of the clouds. These patches of blue are placed according to the natural theme with a certain precision, in a way that its placement suggests the form and the volume of the clouds. It is important to watch the limits of the strokes not through a cross section but from the same spontaneity, trying for the irregularities that might suggest the limits of the clouds. The wheatfield becomes more insistent from longer lines and strokes of bright Yellow Ochre and Cadmium Yellow that suggest the stalks of wheat.

STEP-BY-STEP

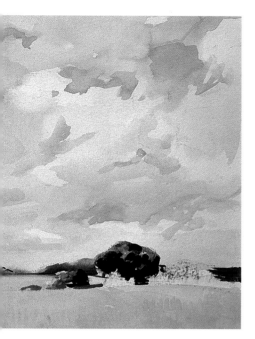

4 This stage of the work is very interesting. I have painted the dark greens of the trees and, upon doing so, the general sensation of the watercolor has noticeably intensified: the yellow appears more intense and the grays and blues of the sky contrast more with the wheatfield. This demonstrates that the intensity of color is not only a problem of choosing the most vibrant tones but of placing both dark and bright colors in a suitable way.

5 In the finished watercolor we see the treatment of the foreground of the field, with the play of yellowed lines that give more definition to the wheat. These lines disappear toward the background, giving the sensation of extensive and dense mass. You don't have to paint every piece of wheat. Paint a few, the rest of the field will be guilty by association. The greens of the trees are much more obscured and reinforce the effect of intensity which also promote the luminosity of a summer landscape.

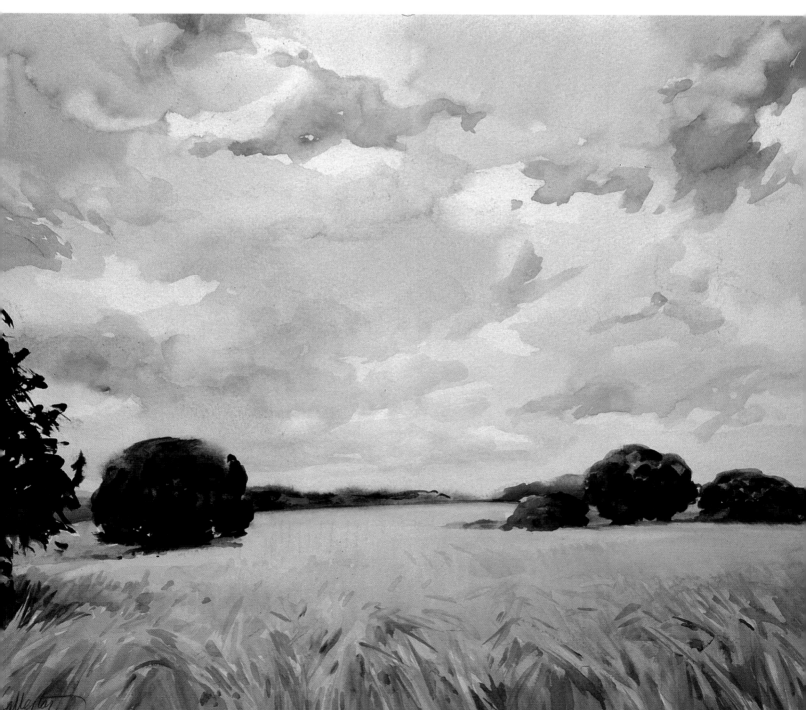

STEP-BY-STEP

Contrasting Colors

The setting that I chose for this step by step demonstration was a vineyard. You should get a lot of practice in this picture with painting trees, actually, they are vines. Look at how colorful they are with their explosions of yellows, red and oranges. Their brilliance is remarkable because the day is so gray. There is no sun to heighten the vividness of color. In fact, had the sun been out, it would have been difficult to paint these colors. You can see how the gray and quiet of this particular day was favorable to the color and purity of the tones.

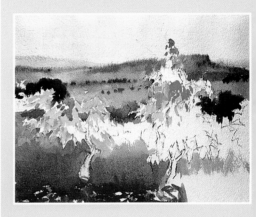

■ *THE PROCEDURE*

The richness of color in this demonstration is its outstanding asset. The warm colors contrast harmoniously with the cold colors in the composition. We can almost speak of it as a symphony in the way that the tones play together in this contrast of accord and discord.

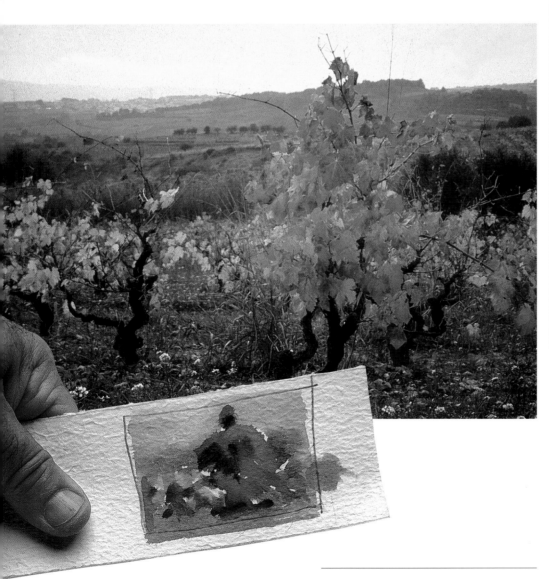

STEP-BY-STEP

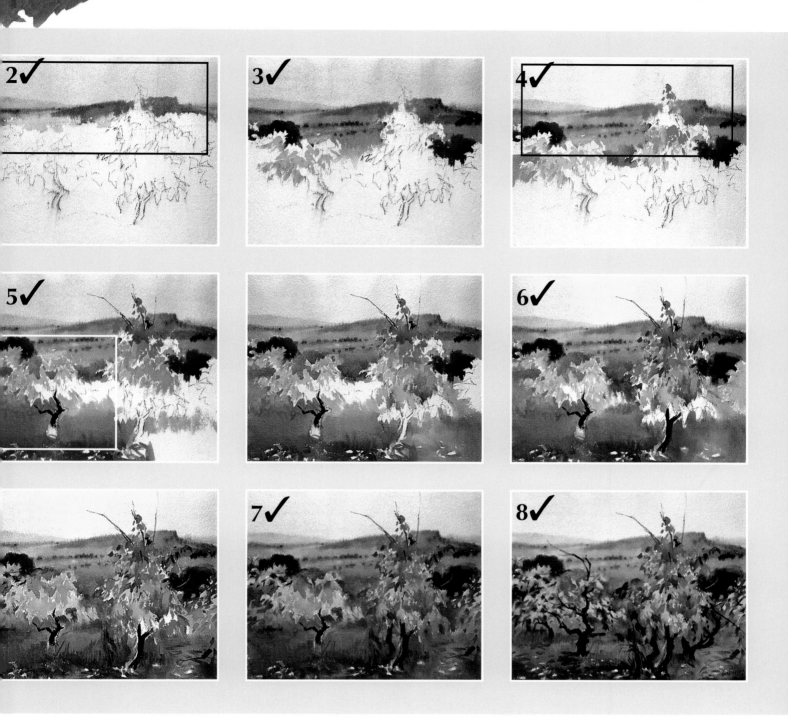

■ HELPFUL HINT:

The palette on which you mix pure color should be clean. This is the accepted norm. This does not mean that you can't mix into this pure color some other colors, such as the earth tones. Your palette, after all, is where your picture is painted, that is to say that all of your color combinations are mixed and tried out there before you commit the color to your paper.

STEP-BY-STEP

1 I did the drawing of the vines directly on my paper, without preliminary sketches or adjustments. For these vines to be in the foreground, I had to take into consideration the details of some of the leaves. Mind you, we do not draw all of them, only those that indicate the anatomy of a vine.

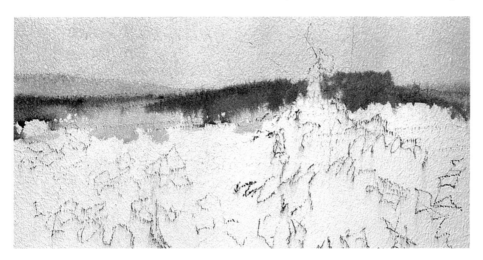

2 We begin, as we should, with the sky. A great yellowish wash gives the tone of the sky. I have applied it in a very diluted flat wash, all of it in the same intensity and color. I have extended this wash to rub against the upper leaves of the branches which jut out over the background. Working on dampness, I have rendered the mountains that are in the background of the landscape, applying very dissolved Burnt Sienna and letting the color blend and trickle over the yellow sky.

3 I continued painting toward the back, and now I begin to encircle the branches with the colors of the background of the landscape. Those colors are very varied and create successive contrasts: the Burnt Sienna of the mountain standing out over the violet of the lower hill to which the yellow has been added. The greens are used to outline the leaves of the vines on each side of the composition. These leaves have been left in white.

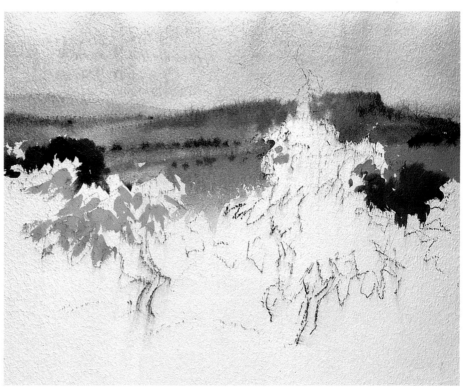

STEP-BY-STEP

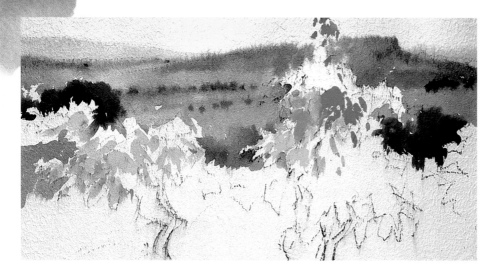

4 I begin to paint the leaves of the branches. I do it by simply looking for the major contrasts, color that might give major intensity to the tones. In the center of the grapevine on the right, I apply small strokes of Cadmium Yellow Medium and Cadmium Red Light.

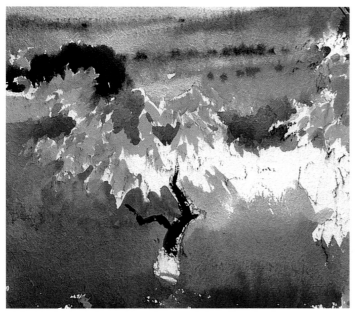

5 I established the leaves of the grapevine as the focal point of this watercolor. Under the leaves I work with a gray green that permits me to continue with the yellow of the hills in the background. With a lot of water, this green blends grays, Yellow Ochre and other greens.

6 While I unify the field in the foreground I will make concrete progress on the foliage of the grapevines, always working with what's left of the white of the paper. In this phase, the foreground and the background have already established contact. In fact, the space of the landscape has already been done and only the foliage remains to play the leading role. Moreover, I have elaborated the color of the leaves, adding some branches that stand out against the sky.

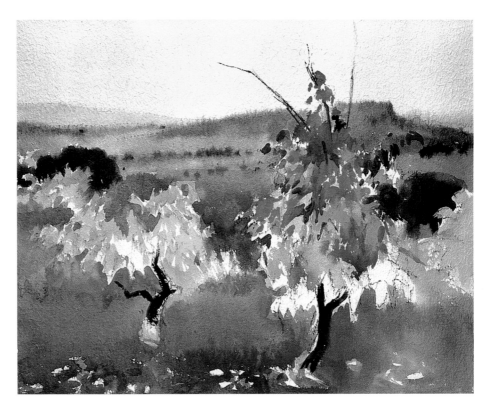

STEP-BY-STEP

7 The watercolor is now completely covered and nothing remains but to blend and intensify some shapes and colors. In the central vine the Cadmium Red has been imposed over the yellow, which appears in contrast to the dominant red. This red darkens to become carmine, in the shadows, and brightens to orange; as a whole it has a toasty appearance that was, precisely, the sensation that I wanted to get with this watercolor. The vine to the left is more blended and has acquired a more precise volume than when the leaves presented a uniform yellow. The trunks are strokes of an almost black color.

8 The finished, full-sheet water-color. From the previous step, there are important differences but they are only changes in tonality that show in some fragments and in the blending of the shadows. The leaves

STEP-BY-STEP

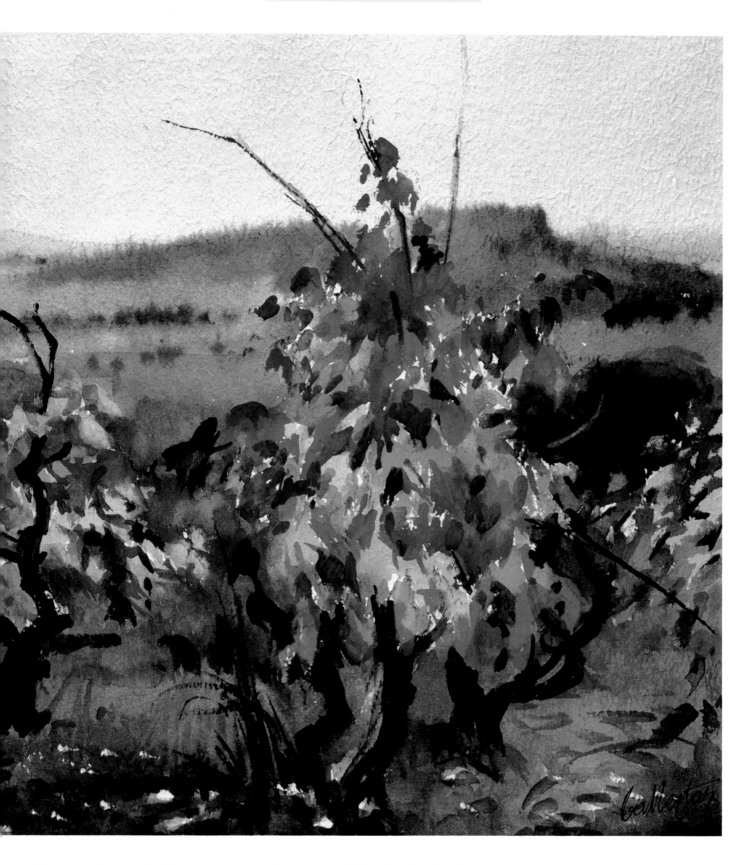

of the grapevine on the left are much more individualized and worked up than before. Also, the stalks and branches are better defined. The base over which the vines grow appears now to be more shaded, with details of grasses and blends of color that supplement the atmospheric quality of the work. I believe that I have assimilated the beautiful color of the theme into a true autumnal representation.

STEP-BY-STEP

A Landscape Without a Horizon

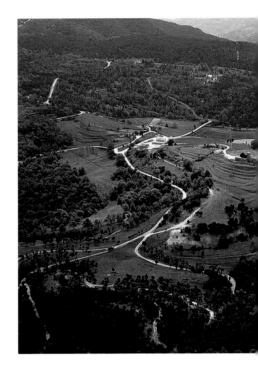

n this demonstration, I have set my easel up on a mountain so I can get a bird's eye view of the valley below me. The painting I will do will be a landscape without a horizon. The view is truly splendid. There is a proliferation of details, shapes and all kinds of movement in the terrain; this causes the composition to be a more detailed drawing than is customary. When composing the landscape from a very high point of view, the perspective that is created by this kind of vision of the terrain delineates the shapes below making them look like they are part of a patchwork quilt.

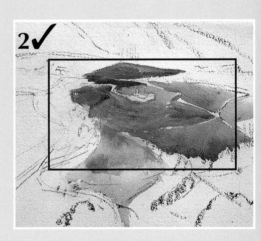

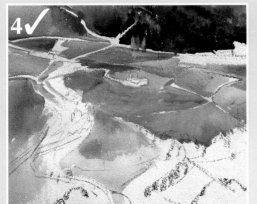

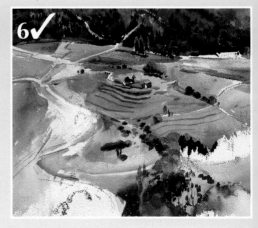

STEP-BY-STEP

■ *HELPFUL HINT:*

To paint a landscape with a high horizon it is not necessary to raise it to the highest point of a mountain; we can elevate it to what we consider is suitable.

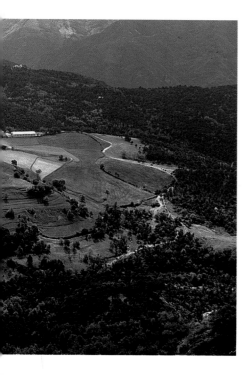

■ *THE PROCEDURE*

In this demonstration the focal point has been established near the center of the composition, which is the area that organizes the rest of the watercolor. You can see it in Steps 2 and 3 on these pages. I usually pick out my focal point when I start my landscape and then, starting from that area, I work out towards the edges of the paper.

The chromatic range here is based in greens, which extend, in the darkest tones, to the blues and, in the most bright, to the yellows.

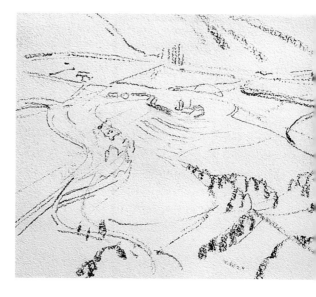

1 The pencil drawing is much more elaborate than initial sketches are in the habit of being for a landscape watercolor. The aspects of the panorama that are of most interest to pick up in this drawing are the ups and downs of the land and the arrangement of the fields. It is important that the lines suggest the level of the hills, their inclination with respect to the observer. The size of the elements has to be in correct relation with all positions in the landscape.

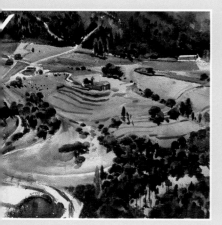

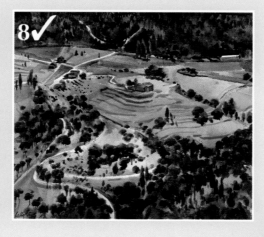

STEP-BY-STEP

2 I work with bright, clear greens, more intense in the center and more transparent toward the bottom. The washes are determined by the boundaries of the fields that I drew previously, but the peripheries are soft and the colors blend at some points. In the lower area, the green is diluted until it suggests a clear gray, which will be the color at the base of the hills of this part of the composition. I have not touched the houses that appear in the upper part of the hill.

3 I paint the background mountain that's covered with trees with a mix of green, Burnt Sienna and blue. It isn't a blend made on the palette but directly on the paper to better control the brightness and darkness of the areas.

4 I continue encircling the central part of the composition with the same tones as before, although with more dissolved color. I pay attention to the drawing of the roads in the highest part of the composition. Those same lines lend sensibility to the form and the ups and downs of the mountains. In the upper left part of the landscape you can see the change among the fields, the central hill and the exterior boundaries of the landscape; there is no sudden jump in the intensity of color, but subtle changes in the tone that unify the panorama. The washes are made more lightly and softly toward the lower left part so as not to overburden the landscape with any kind of precision and unnecessary details.

STEP-BY-STEP

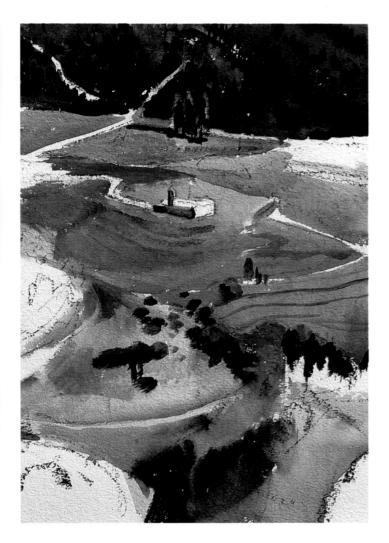

5 I begin the rendition of the mountains at the lower part of the composition. This part I had left simply washed in with gray in the first phases, blending with the greens in the center of the landscape. The treatment of the wooded area in this part should be loose and varied, without applying a similar type of stroke or shape for each tree or group of trees. In the image, we see distinct shapes and strokes of a dark green. The characteristic of these washes is their feeling of proportion. Among other details, that now begin to take form, is the house on the central mountain. I have shaded one of the house's sides.

6 The central part of the water-color is almost completely finished. The treatment of the slopes is evident, with the escalating succession of banks to that which makes the incline visible and also shows up the texture of the grassy surface. Some small trees have been included and gives the idea of scale and of relative sizes. The lower part is already very populated with trees, to the point that these compose a dense mass with little definition.

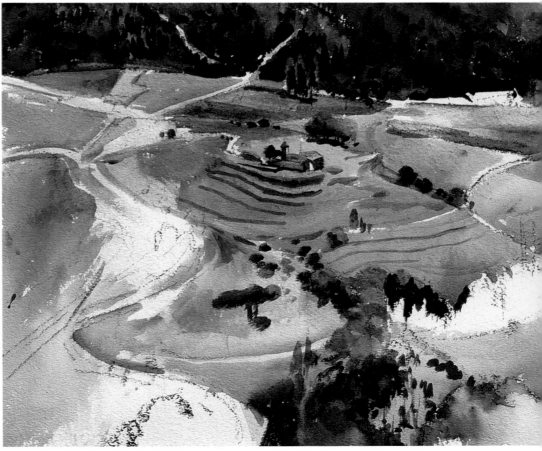

STEP-BY-STEP

7 We see how the incline of the mountain on the left of the composition has been made clearer and more explicit than before, thanks to the modeling of the grayish greens. In effect, most of the hills of the foreground is made of soft modeling on which I have superimposed the strokes of the trees. The whole landscape is now populated with houses and trees that give a monumental quality to the panorama.

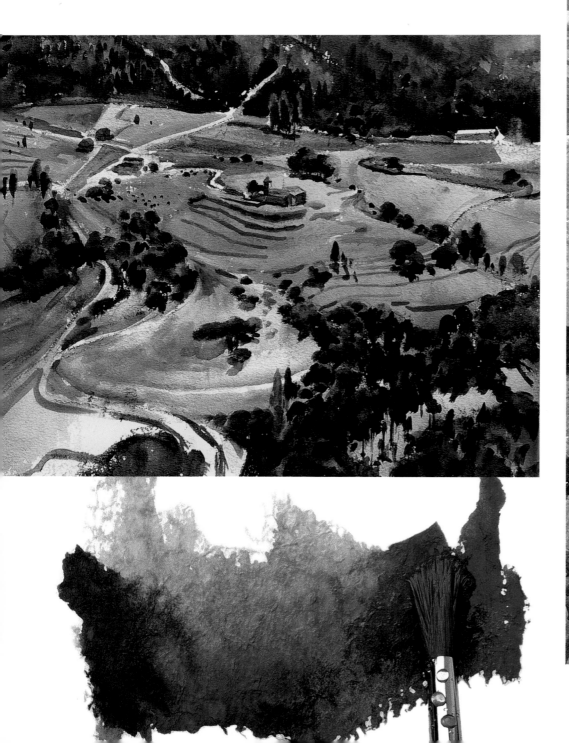

STEP-BY-STEP

8 The finished painting. As you can see, this is a more laborious demonstration than others in the book. In this final stage we can study the closest boundary, in the angle to the lower right of the work. The relationship of this slope comes from the size of the trees, and its continuity with the rest of the landscape.

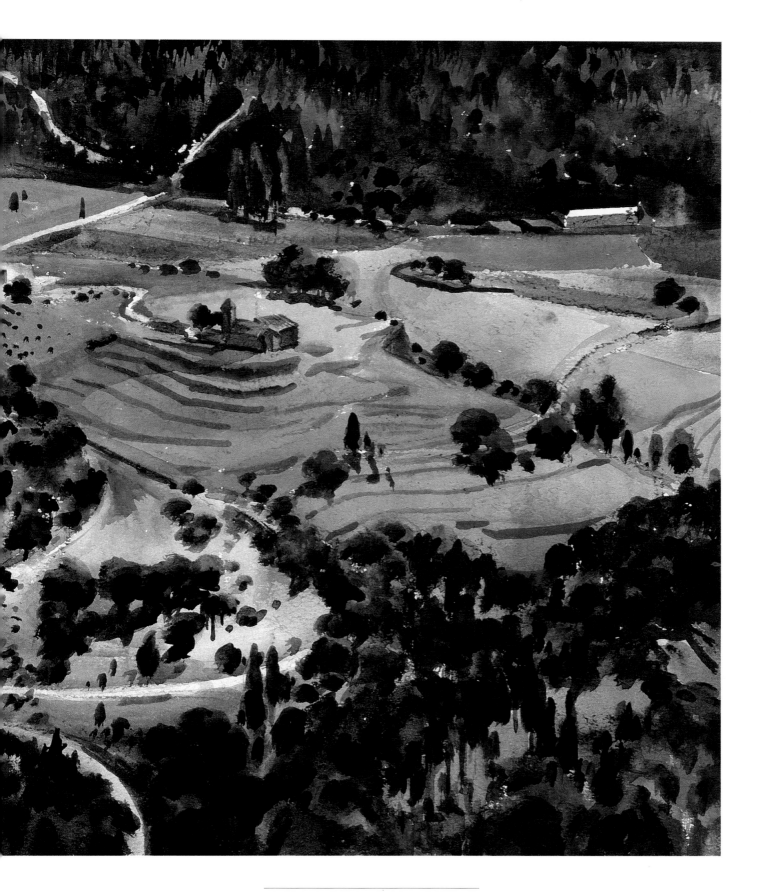

THE COUNTRY

Warm and Cold Greens

Vincent van Gogh, The Cypresses, Metropolitan Museum of Art, New York. In these grand cypresses the green that was used for them is not unique but many of them are interwoven through curvy paint strokes that give color to the trees and determines and creates the movement and rhythm of the landscape.

Paul Klee, In the Quarry. Paul Klee Foundation, Berna. While to many, the painting, seen at right, may not be a valid landscape, it is the artist's interpretation, captured on the spot.

WARM GREENS

The title for this item seems to be a contradiction, because we all know that the color green, along with blue and violet, belongs on the cold side of the spectrum. How, then, can there be a warm green? It's simple when you realize that in reality, green is the warmest cool color. Green, a secondary color, is a mixture of blue—a dark spectrum color—and yellow, the lightest color of the spectrum. Green, then, can vary from cool blue greens to very warm yellow greens. Since most of of the greens seen in nature are yellow in hue, we think of these greens as being warm. You get this by adding amounts of tubed green into a yellow. Blue greens, on the other hand, are not as readily seen in nature. Normally, you would get warm greens through the mixture of other warm colors that would modify tube greens, especially if you want light greens. Mixing green with earth browns, for example, will give you a warm green that is lightened by using less brown color in the mix. Yellow Ochre is a key color to mix to get a warm green; orange is another one.

COLD GREENS

Cold greens, bright or dark, are how all the greens come to us in tubes from the manufacturer, with the exception perhaps, of olive green, whose tendency is toned down or

The stunning landscape by Ballestar (at left) orchestrates multiple greens along with the participation of grays and neutral tones within the chromatic harmony. Once the neutral tones are introduced, the artist can integrate them into the work of multiplying the blends and discovering new and fresh relations of color.

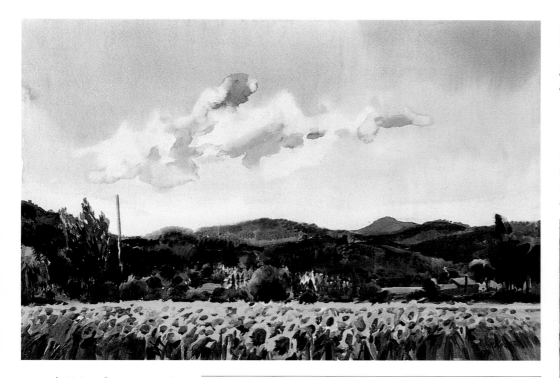

The greens in this landscape by Ballestar (shown at left) contrast with the yellows of the foreground: yellows that hold the greens in a cold vein.

Gustav Klimt, Plantation. Private Collection, Vienna. The greens throughout this piece are warm and subtle.

neutral. Using these greens in producing a tree-laden landscape, gives a result of a green that's much colder than natural. This is due to the nature of the pigments, of tonality more pure and cold than that of natural greens. Cold greens also are those which promote blends of yellow with distinct blues and in different proportions, or that they get from mixing that yellow with other greens.

Another important range of cold greens are the blue greens which, mentioned earlier, are not as prevalent in nature. Used with moderation, they give to the color of the landscape a characteristic luminosity. Its use, as we have said, should be moderated because they tend to become a bit artificial if used in excess.

HARMONY OF GREENS

The extensive range of green colors at our disposal need other distinct colors to create attractive harmonies. By themselves, these greens are monotones and a bit dead because, although they can contrast in tone, the intensity and the temperature appear without animation. In any harmony in which the greens dominate, therefore, it is necessary to mix in brown tones, reds, oranges or rosy tones to introduce a chromatic vibration. Since these colors are not present in a natural landscape, the painter can always find thematic excuses to use them on a rooftop, a rock, the stretch of road, etc.

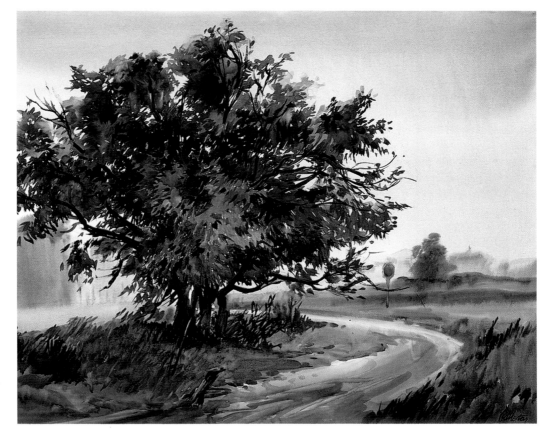

The impressionist technique of soft and light paint stroke is an excellent method of composition for chromatic harmonies. The light quality of the foliage of this tree is due to the paint stroke as well as to the juxtaposition of different green blends that contribute to the expression.

Shadows

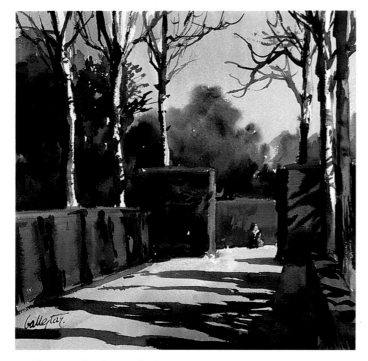

In this watercolor the cast shadows play a fundamental role in the composition: they create a perfect right angle with respect to the vertical thrust of the trunks.

SHADOWS AND COLOR

The colors of cast shadows are complementary to the colors on which they fall. This is a truth of physics and optics. Even though the Impressionists drew attention to how the shadows of the landscape in full daylight tended to be bluish, at times bright and transparent and at times of an intense violet color, the principle of the role of complementary color in cast shadows, as expressed above, is a painting truism.

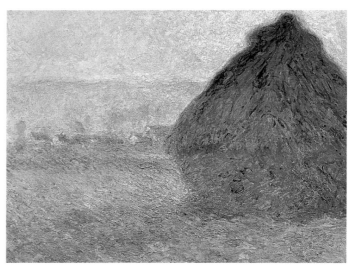

Claude Monet, Straw Loft. Museum of Fine Arts, Boston. Shadows and color are indistinguishable in this impressionist work.

SHADOWS AND VALUES

Shadows are some of the factors that are responsible for the values of a landscape. Values are the distinct intensities of bright and dark colors. The intensity of shadows depends on the description of light. A very sunny day creates intense shadows and very bright lights.

Shadows, by being the dark colors of the composition, resolve themselves in the ultimate phases of the work, after all the rest of the colors have been resolved.

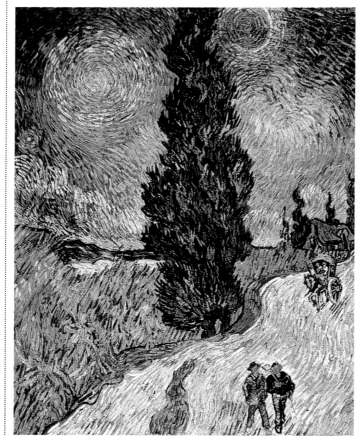

SHADOWS AND FORMS

The intensity of shadows tends to make forms disappear in the darkness. The painter can play with this factor creating plays of light and shadow independent of the real forms. It is in the procedure of *chiaroscuro* where forms lose their contours.

Vincent van Gogh, Road with Men Walking. Rijksmuseum Kroller-Muller, Otterlo. In this landscape, there are no shadows cast by the elements of the composition, but these are liberties that modern painters take and have taken.

The intense shadows unify the composition. At the same time, the pure contrast of color, the position of warm and cold colors and the juxtaposition of complementaries suggest the shadows without the necessity of being represented.

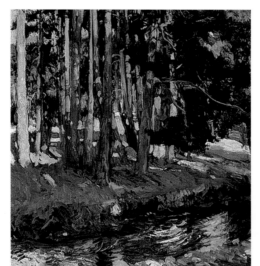

John Singer Sargent, The Stand. Private collection. In this magnificent watercolor, the shadows shorten and cut the vegetation forms: shadows of the leaves combine with shadows that are broken through other plants to construct a sensation of fresh and dense vegetation.

LANDSCAPES WITHOUT SHADOWS

On those days when clouds appear low in the sky, the shadows disappear. Without shadow, objects are seen in their natural intensity, isolated one from the other, perfectly drawn and each with its own unaffected color. For many artists, this is the perfect light for painting landscapes. It is treated by painters that look for the precision of the drawing, the exactness in the details and the composite clarity, as the perfect lighting definition. The absence of shadows doesn't imply the absence of tone values. When shadows disappear the tone values come through the lightness or darkness of the color of the elements of the landscape, through the play of continually active contrasts. The two options (landscapes of intense shadows or landscapes without shadow), have their inducements and in both the artist can find motifs that bring him to complete a landscape of quality.

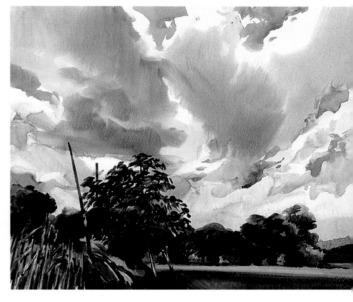

Joaquin Sorolla, Pines of Valsain. Sorolla Museum, Madrid. Looking at the work at the right, we see that the major part of the motif is found submerged in the shadow. The light is reserved for the tree trunks of the background.

The luminous effects of the passage of clouds over the landscape are an opportunity for discovering combinations of light and shadow. In this landscape by Ballestar, the vibrations of shadow are placed in a way that suggests the passage of the clouds over the panorama.

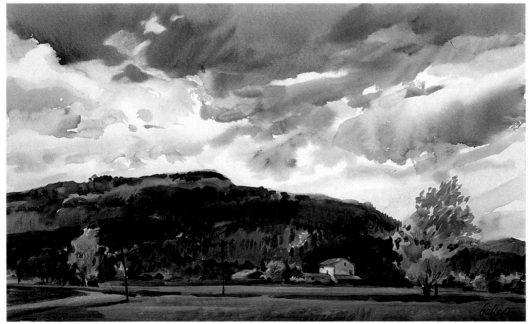

Cloudy days without wind reduce the shadows of the landscape to almost nothing and give a calm and clear appearance.

Trees and Mountains

Wen Tcheng-ming, Pines and Cypresses. Palace collections, Taiwan. This work of the 16th century demonstrates an admirable fantasy in the treatment of the trees, the drawing of its branches and their distribution on the paper.

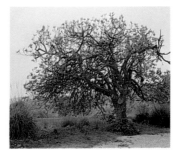

Here are two examples of trees that are very distinct in their forms but equally interesting from the point of pictorial presentation.

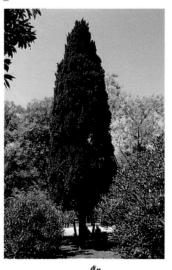

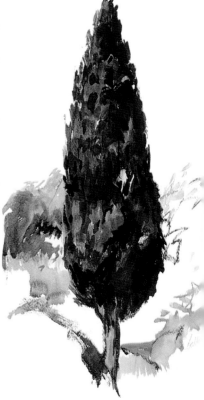

LANDSCAPE PROFILES

Trees and mountains are fundamental elements in the profiles of landscape, especially when they are treated in a landscape of low horizon where forms are cut against the sky. Getting this correct is a problem of drawing that has to be done with preliminary sketches.

The irregularities of a horizon that's popu-lated with trees or of mountaintops always can be one of the motifs when these irregularities are beautiful within their own rhythm. In a very mountainous landscape, for example, the sky can fit in between two mountains. The whiteness of the sky surrounded by the major darkness of the landscape is a visual factor of the first order. Another interesting case is of the sky that's seen between the branches of the trees, crossed through the drawing by branches that create ornaments lacing the sky.

An olive tree (photo above, painting at left) is one of the most attractive natural forms for the painter: the form, the line, the lights and shadows provide ideal motifs to achieve a successful watercolor.

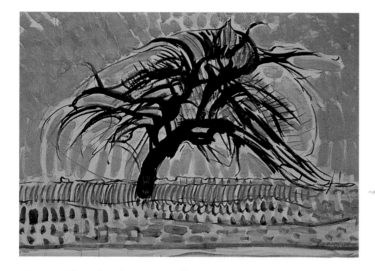

Piet Mondrian, The Blue Tree. Haafs Gemeentemuseum, The Hague. Through his insistent study of the form of trees, Mondrian is represented here by his stylized version of a tree.

SKETCHES OF TREES

Trees, like all natural forms, also can be planned through basic forms. The easiest of all of them is a sphere that unifies the treetop and the branches. This figure is enough to be able to paint different types of trees, but apart from the sphere or ball the painter can derive other more appropriate forms like spindles and cones for cypresses, firs and other geometric shapes that can be used to describe a lot of different types of trees.

Sketches help to compose the total form of a treetop as a closed body. Trees open and extend in a more linear form; the curves of the branches cover an importance equal or more than the volume of the foliage. In these cases the forms combine the basic anatomy with the three dimensions. The anatomy will be represented through squares, triangles, rectangles, etc.; a three-dimensional effect can be suggested through ellipses that can visually be understood as circles in perspective.

In practice, painters go through very simple forms and combinations. What is important is that the artist understands correctly the peculiar form of the tree in question and is capable of explaining it through a planned, useful sketch.

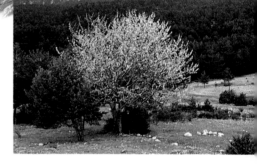

A peach tree in blossom is an irresistible theme for the painter. Painting with watercolor is a matter of playing with the white of the paper and leaving areas without any color for artistic effect.

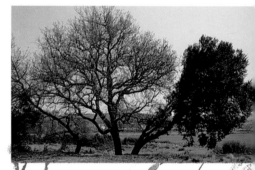

Bare branches are a complicated theme and one that requires attention. It's worth the trouble to take time to study and see the principle that governs them, translating this to the paper.

SKETCHES OF MOUNTAINS

Mountain sketches are much easier than trees sketches, simply because the artist does not look for the structure of the entire mountain but stays with sketching only the limits of the crests. These crests can be very irregular (in a landscape of high mountains, for example) and at times it is convenient to simplify a bit and harmonize the jagged rocks that are drawn against the sky. In any case, the painter always should look for a certain linear harmony in the drawing of the mountainous horizon.

Rocks and Buildings

THE COLOR OF SOLID STRUCTURES

Buildings are the man-made solid structures of a landscape. These elements are subject to changes of atmosphere, of light and of color in general. The color of the structures in the landscapes (barns, thatched roof houses, farmhouses, etc.) can be employed as focal points, chromatic accents that animate the composition. The roofs, for example, especially the ones with their red colors, can create interesting contrasts within the environments that are so green with vegetation.

The color of the buildings is affected not only by the light and shadows but also by the reflections. Treating the white surfaces, the walls of the houses harmonize with the color of the trees, of the greenery or of any nearby object. A leafy tree that receives direct sunlight together with a white wall will take a light green tone that the artist can use to advantage.

Some buildings also can offer interesting possibilities in the matter of texture. The ruggedness of its surface and the square angles of the stones can lend a decorative note to the realism of the forms of the painted landscape.

Caspar David Friedrich, Ruins of the Abbey of Eldena. Private collection. Ruins as elements of a landscape were commonly employed during the Age of Romanticism; the artists interpreted the form of the old stones.

Charles Demuth, Houses with Red Roofs. Philadelphia Museum of Art. In this watercolor, seen below, the architecture and the color of the houses creates an autumnal pictorial plot, despite its strong cubist treatment.

Francis Towne, The Fountain of the Aveiron. Victoria and Albert Museum, London. The interpretation of the rocks, which are natural formations in this work, are characterized in a special way. The painter imposed his own vision and characteristic style to give unity and coherency to all the forms.

ROCKS

Bare rocks in landscapes pose a color problem. In general, rocks do not have a very defined color like other elements of the landscape; we tend to see them as a gray, more warm when seen in sunshine. These rocks are marvelous elements in a painting because they possess their own characteristic

color and are fantastically textured.

The artist can choose to treat rocks abstractly as design elements in the composition or in a realistic manner, reproducing its details and distinguishing one from the other. Both possibilities are perfectly valid except if one is foolish enough to use both interpretations in one painting.

John Singer Sargent, A Tent in the Rockies. The Isabella Stewart Gardner Museum, Boston. Architecture in a landscape doesn't always have to correspond to ancient structures or ruins. In this case, a camping tent hits the mark in a setting that the artist obviously felt close to.

Wai Kia, Landscapes in the Spirit of the Poetry of Tou Fou. Palace collections, Taiwan. The interpretation of this landscape is as an exaggeration of the vertical form of the mountain.

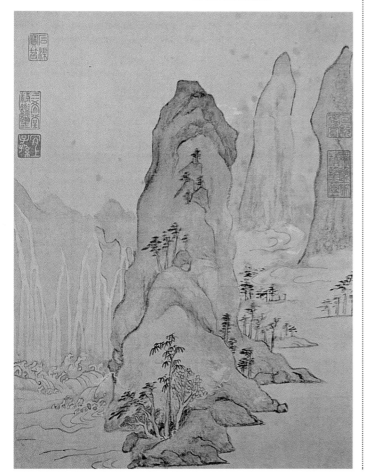

ARCHITECTURE

Of all the thousands of landscapes that have been painted over the centuries, there has been a fair number that included man-made structures. It makes sense for artists to seek out these objects to be used as compositional aids to their pictures. Old barns, shacks, huts, walls, fences, even wrecks of cars, can introduce interesting notes of color, texture and human interest to static landscapes. Upon looking at Andrew Wyeth's famous

John Constable, Stonehenge. Victoria and Albert Museum, London. This incredible prehistoric monument has long been an inspiration for artists.

tempera painting, Christina's World, don't you wonder about the house that Christina is striving to reach?

On these pages, you will find paintings that make use of natural forms and man-made buildings to help heighten viewer interest. Some paintings succeed, others fall flat.

Yves Tanguy, Untitled. Peggy Guggenheim Collection, Venice. The surrealist painter Yves Tanguy became a celebrity thanks to his mysterious landscape visions, such as the one that's pictured here.

Summer Landscape

Claude Monet, Wheatfield. Cleveland Museum of Art. Monet gave marvelous interpretations of summery fields, with admirable freshness of color and great loyalty to the summer atmosphere.

Claude Monet, Plum Trees in bloom in Vetheuil. Szepmuweszeti Museum, Budapest. Fruit trees in full splendor occupy the foreground of this work: summer was one of the great landscape themes of the Impressionists.

WARM COLORS

If we have to select the least popular season for landscape painters, we would have to say that it's summer. First of all, for the most obvious reasons: heat and insects. Second, and less obvious, is the natural annoyance of painting at a time when the vegetation is at the height of lush, full growth, and with it a dominant coloration of deep greens. How boring! In the spring, however, the painter enthusiastically faces frivolous yellow greens and other great combinations of a new season's lively colors. Certainly in autumn, there's always the sensuous excitement of the red, yellow and orange foliage. And in winter, aside from the discomfort of the biting cold, painting the bare beauty of nature carries with it an untamed excitement.

When Vincent van Gogh traveled to Arles, in the south of France, he was confronted with an explosion of color he had never seen, not in his native Holland, not in the environs of Paris. The fiery color of van Gogh's Arles landscapes responded to his vision of nature, aided by a natural reality. His summer wheatfields are distinct blends of pale yellows, Lemon Yellow, Cadmium Red, Yellow Ochre and oranges. All these colors created, for him, a rich chromatic blueprint from which many artists have learned a lot.

It is this warmth of color, contrasted by cold complements of these yellows—the violets—that stand out and give body to the yellow strokes. The most intense colors are nothing if not applied in the correct proportions and accompanied by their corresponding toned-down complements, that is to say, more neutral tones. This dependence on toned-down colors, or grays, should always be remembered by the artist who likes to intensify the most vibrant tones of the landscape. Grays and toned-down colors can be found in shadows and in the turning edges between the light side and the shadows.

Vivid colors faithfully represent the intense light of summer landscapes. This light intensifies everything and makes all the tones vibrate but the painter has to neutralize it with grays and toned-down colors to give validity to the most pure colors.

SPRING AND SUMMER

We have been speaking of the deep, lush greens of summer. Many of these greens have a clear bluish tendency that almost all watercolor landscape artists know and choose in their work.

Spring, as mentioned earlier, is also rich in greens but they are different kinds of greens. Cold, fresh, with a vibration in its color. Furthermore, spring abounds in luminous colors, the colors of flowers that make a deep impression on the landscape.

Speaking of flowers, it is necessary to say that many artists do not get entrapped by the decorative excess of flowers, preferring a more sober treatment of color. The choice remains the artist's. Nothing is forbidden in principle, and a floral-laden landscape, if it is treated with honesty and with attention to the model, can have an enchantment that's new and free of trite themes.

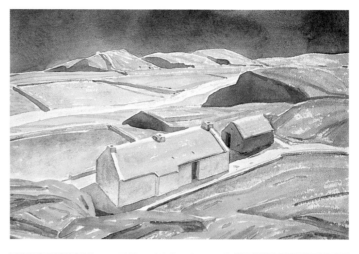

Rockwell Kent, Home in the Country, Worcester Art Museum, Mass. The colors in this watercolor go far beyond that of the naturalness of summer colors. The artist, however, chose not to limit himself to a rendition of natural tones.

Claude Monet, Field of Oats with Poppies. Museum of Modern Art, Strasburg. The predominance of color in this spring landscape is accompanied by the gentleness of the atmosphere.

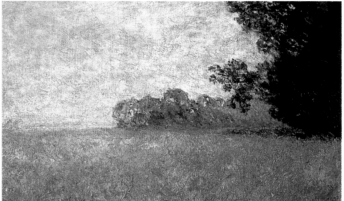

Claude Monet, Field of Poppies. Smith College Museum of Art, Northampton, Mass. This work deals with a moment of summer calm in the fields. One can sense the heat and immobility of the atmosphere as expressed by this French Impressionist.

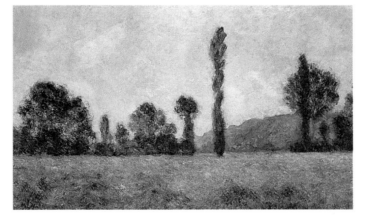

Edward Hopper, Foreground of the White River. William Emerson Foundation. The curve of the river and the monument-like trees provide the perfect complement to the light of the late afternoon.

Edward Hopper, Village. Whitney Museum, New York. More of a painter of urban scenes, Hopper's landscapes were always sincere and faithful to the moment and the season of the year.

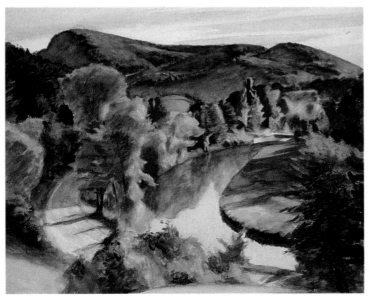

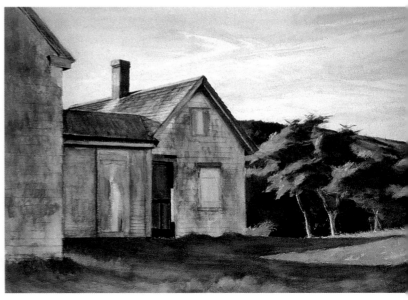

Autumn and Winter

For many artists, autumn is the most picturesque time of the year. The moment in which the siennas and toasty colors impose themselves among the greens and are enhanced by them; trees begin to be outlined against the sky and the earth is covered in reddish and yellowish tones of an extraordinarily pictorial attraction, as in this landscape by Ballestar.

William Russell Flint, Light and Shadow. Private collection. This work reflects the fascination of the artist of the spectacular changes of a fall landscape, accentuated by effects of bright and shadowed color.

AUTUMN

Study the variety of colorations of fall landscapes and you will see that they correspond with a series of pleasurable warm colors of the palette. The warm colors of fall are richer and more varied than those of summer. Fall is, without a doubt, the season of chromatic treasures. The chestnut colors of carmine, toasty sienna, Cadmium Yellow, orange, vermilion are all agreeable ranges. It has already been said that the ranges of browns (earth tones) and siennas were some of the widest of the palette of the landscape watercolor artist. The autumnal landscape is the ideal theme to unfold these ranges.

In landscapes full of trees with old leaves, autumn colors are on fire with direct sunlight and create a surprising variety of rusty and golden hues.

Gustav Klimt, Grove of Beech Trees. Osterreichische Gallery, Vienna (below, left). A precise and detailed representation of an aspect of autumn: a grove of trees covered with leaves.

Philip Jamison, The Grange of Willinstown. Private collection (below, right). The end of winter with the melt and the appearance of spring greens: another grand theme for the landscape artist.

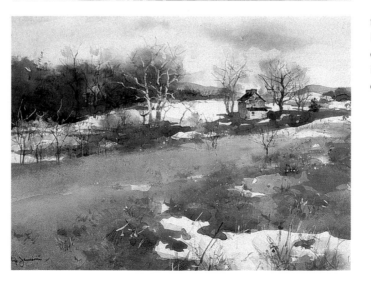

VINEYARDS AND FRUIT TREES

In the area of vineyards, for the artist interested in painting them, autumn is the ideal season. Vineyards at this time of grape harvest are prodigious in honeyed and toasty coloration

Fruit trees are another perfect theme for autumn. They, like the vineyards, display colors at this time of year that indulge the artist with a wealth of pictorial opportunity.

The skies of autumn and winter have a particular richness and offer an advantage: they are more dramatic than the skies of spring and summer. The painter has a full range of color at his disposal for the rendition of these special skies.

WINTRY LANDSCAPE

Winter is the season when nature is presented in gray, a sort of *chiaroscuro*. It is also the moment of toned-down (or chromatically reduced) colors, of deadened ranges little defined by warm hues. To speak of cold colors is to speak of an immense variety of colors governed by certain dominant tones that come from blue and gray. Blues that go from the tone of a calm sky, gentle and sensuous, to the ultra-cold Prussian Blue of storm clouds. As for the grays, we go from the ones that vibrate between the silver of the mountains to the dark, cold grays of rocks. The toned-down tones shift between these grays and blues and can offer a warm tendency or an overcast and more cold gray that moves toward the more green gray.

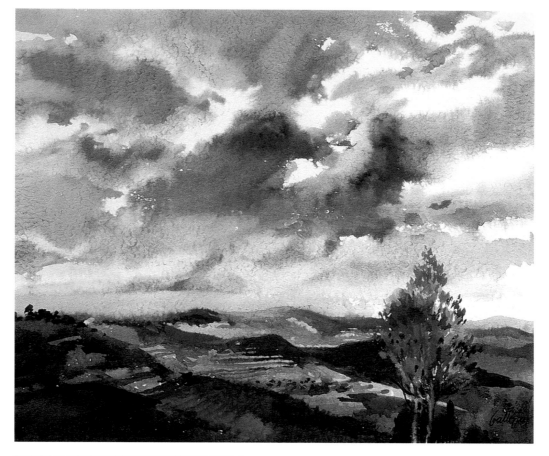

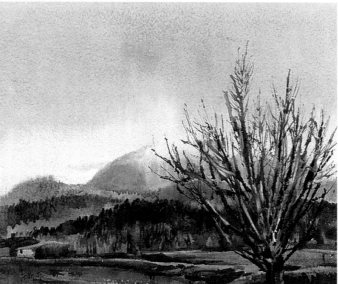

At left, the bare branches cut against the sky is a characteristic theme of winter landscapes. These branches can be the organizing element of the landscape, the central motif around which the rest of the panorama moves.

Charles Burchfield, Night scene. Whitney Museum of American Art, New York. This American watercolorist develops a scene of nightfall at the onset of autumn.

Edward Seago, The Marsh of Norfolk in Winter. Private collection. The bareness, the sparseness of color and the composite simplicity do not stop the artist from producing a rich expression of the theme.

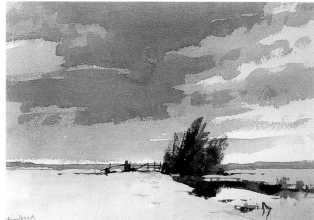

The Snow

WHITES AND GRAYS

Snow is white and in a watercolor, snow is a matter of saving whites of the paper. We know that in oil colors, pure whites are rarely, if ever, used. The purist feels the same way about the use of white in watercolor. White always has to be blended, lightly grayed by other colors. This graying of the white is necessary to make landscapes look natural. On very few occasions in a snowy landscape is a white used pure and without blemish. The white of the snow goes gray and blends with the colors to agree with the conditions of the lighting and with the characteristics of the landscape. A very thin layer of snow, obviously, permits you to see the

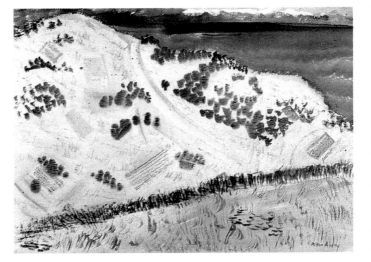

Milton Avery, Road to the Sea. The Brooklyn Museum, New York. The simplicity of the rendition of this watercolor and the representation of the themes fit very well with the artist's vision of a snowy landscape.

mud and the grass of the ground. A lot of snow, while stark white, is still affected by colorful shadows and reflections of nearby objects.

SNOW SHADOWS

Shadows in the snow are an attraction for any watercolor. They have a pureness and a transparency that is tailored for watercolor painting. In a snowy landscape illuminated by the sun, the shadows on the snow are, in most cases, painted with blue. This can be seen by all observers, be they painters or not. Of course, shadows can be made of other cool colors, such as tones of violet. Here's a rule: since snow that's been illuminated by the sun is warm, a cold complement has to be used for the shadows.

The experienced watercolorist, who is well versed in the craft, knows that in order to paint snow the shadowed

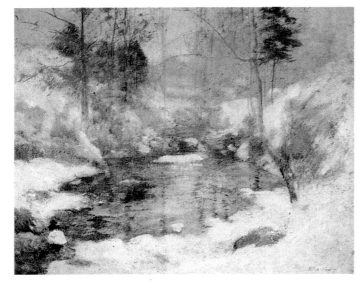

John Twachman, February. Museum of Fine Arts, Boston. Snow and water present mixes of the kind where appearance depends upon certain conditions of light. The artist has applied himself to the detailed development of these mixes.

John Twachman, Winter Harmony. National Gallery of Art, Washington. The title already suggests the artist's intentions: he composes an interesting chromatic harmony through the theme of snow and water. Twachman captures the purely chromatic interest that includes the fallen snow over the landscape.

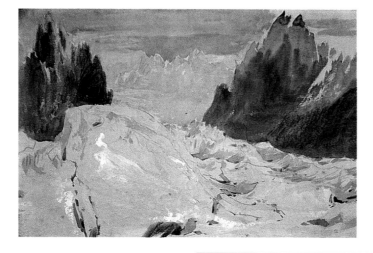

J.M.W. Turner, The Ice Sea. Private collection. The choice of a glacier as an artistic theme is very significant: the artist is of a romantic temperament, given to grand and dramatic spectacles of nature.

areas are essential. There is little room for mistakes in watercolor painting; when the subject is snow, there's even less room for error. To obtain the sensation of whiteness and of purity, the work should be delicate and without correction with any opaque applications of whites or yellows. That is a definite no no!

Choosing a landscape of "old" snow, dirty from mud and the earth beginning to appear under it, can be a very interesting idea. The combination of the pure white and the brown colors, with their corresponding intermediate transitions made of dirty grays and toned down colors, give a sober harmony that's very expressive of the winter character.

DIRTY SNOW

Snow that has become dirty is usually what happens to snow on city streets. Snow can also get dirty out in the country. The dirtiness is a fusion of the earth and snow that promotes multiple toned-down colors. Portraying these colors means painting with alternating touches of pure color with a wash of color so that the color of the paper appears in transparency. In a landscape that presents these characteristics, it will always be possible to darken whites using water and blotting up the dampness with the brush until the white in the paper is in relation to its surroundings.

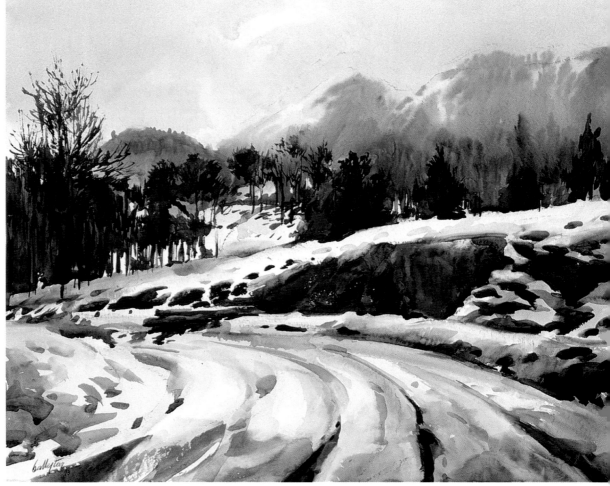

The Greens in a Mountain Landscape

The setting for this watercolor demonstration is one dominated by greens. In the photograph (seen below) you can recognize most of the greens. The green of the valley is delicate and saturated, contrasting with greenish blue of the soft lakes. That's somewhat reduced with a green tending more toward Yellow Ochre. In this step-by-step progression, I intend to address the whole concert of greens, from the yellow hues to those of the blues.

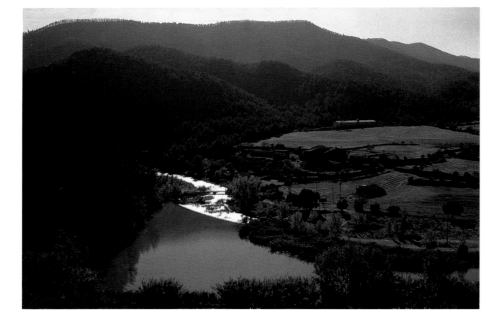

■ THE PROCEDURE

The rendition of this watercolor has enough work of mixes in the palette, of the search for distinct greens, not only through the given colors, but through previous mixes that I have chosen as the basis for new colors. In the warm greens, the process has passed through a yellow or Burnt Sienna base that has been blended and makes it turn toward green.

1 The pencil drawing (at the top) contains enough detail that's placed in a way that there are many things included in this composition. In the drawing, you can appreciate the general structure of the landscape, designed around a great central oval. The rest of the planes are limited to surround this oval in

■ HELPFUL HINT:

Chromatic ranges in general, and greens in particular, are enriched mutually on the palette: the resulting mixtures can serve as a base for new mixtures that can give up new colors within the same range.

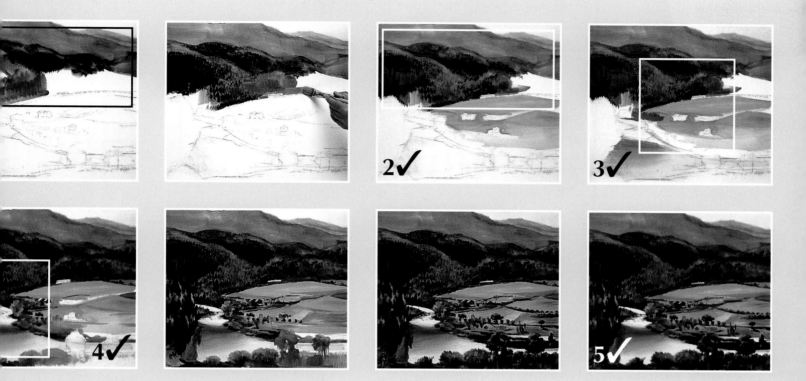

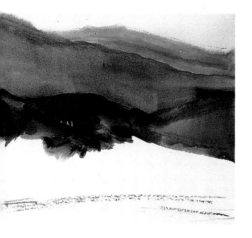

2 We see here the work that I did in the mountains in the background; it's necessary in these mountains that we get the ups and downs of the slopes. They are the result of mixtures of blue and green for the shadows and of green and a pinch of Yellow Ochre for the light, bright parts. It is interesting to study the method of getting the dense forest through small touches of the point of the brush with a very dark color, which is a blend of blue and green. On the dark side, these paint strokes may continue, but they end up fusing with the tone of the base. In the center of the composition, they appear as the warmest and clearest green.

the foreground. I have started the color in the upper part of the water-color with a fairly dark wash of blue mixed with a little carmine. This embraces the mass of the mountains in the background. Through Ultramarine Blue, I will work the mountains that precede it, retaining them to the borders of the oval.

STEP-BY-STEP

3 At this point, the structure of the landscape is almost complete, thanks not only to what is painted, but also to the white areas that have been planned to remain on the sheet. An important and interesting detail is the treatment of the river which appears clear as a crystal, mirrorlike and without any movement.

4 The area on the left, which before had been left white, now has been rendered. The colors are the same ones I used in the mountains of the background: intense blue and green. The paint strokes here, however, are considerable, which makes this part of the painting appear closer. In the lower part, we see another, more gray section, which functions as the shadow of the large slope projected over the river. The banks of the river have already been completed; it is where the greens clearly turn toward the bright yellows and the Yellow Ochre, carrying the warm notes of the painting. When you compare these colors with those of the photograph on page 82, you can see how I have exaggerated this warmth with the aim of stressing the contrast.

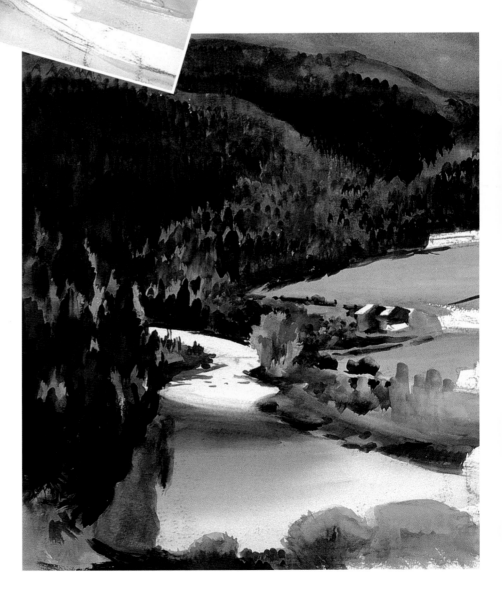

STEP-BY-STEP

5 In the finished painting, there has been considerable work done on each of the masses of the foreground. Over the warm colors, I have blended new greens composed of distinct mixtures, in a way that the Yellow Ochre and yellows, put in previously, now become integrated in the general green harmony. The previous warm tones may continue now as warm greens. This is seen clearly on the edge of the central meadow where the Burnt Sienna takes on an earthy green mixture and where I have included all of the details that populate the composition. The river, completed in the first phases of the work, was left intact from that first point.

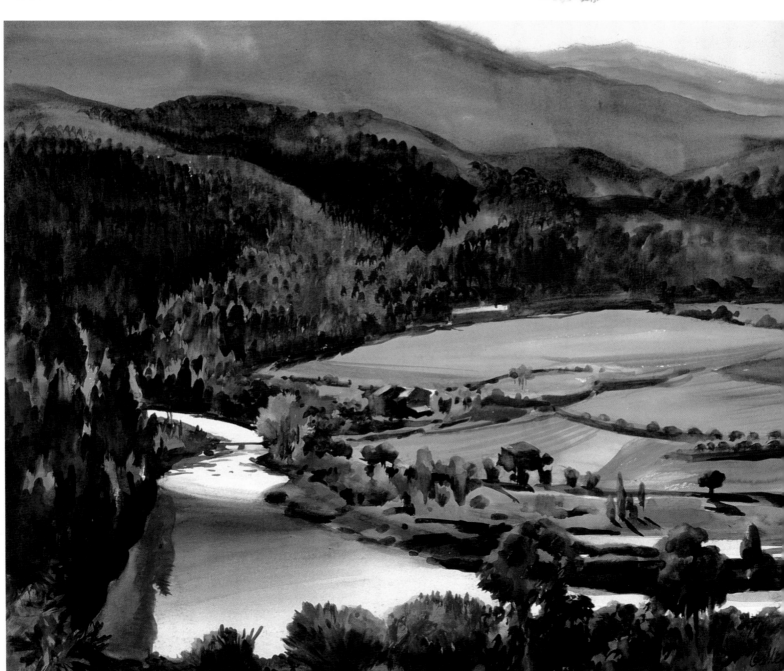

STEP-BY-STEP

A Rocky Landscape

*R*omantic watercolors flourish with themes of this type; its origins go back to medieval painting in which the landscapes were composed of folds of rock, from which a tree or some plant sprouted here and there. Rocks certainly have their own attraction. Many painters look for themes where rocks can be the stars. Their color and their ruggedness are good points for studying and representing their forms.

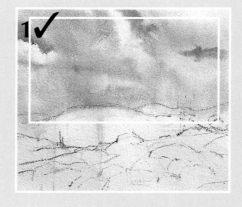

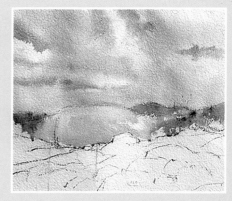

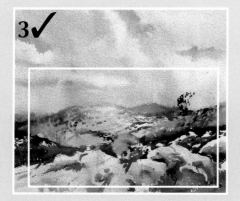

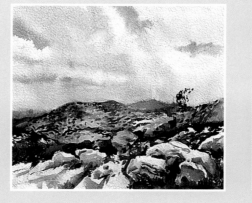

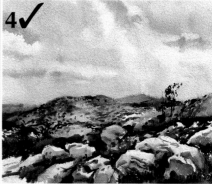

■ *HELPFUL HINT:*

Rocks have a formal richness, which can suggest to us almost a sculptural mass of incomparable grace and visual interest.

STEP-BY-STEP

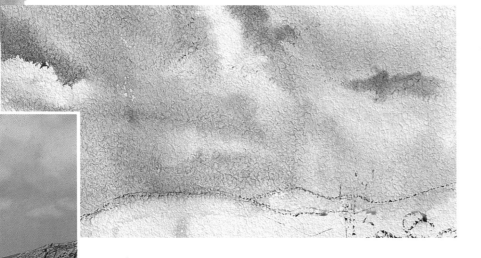

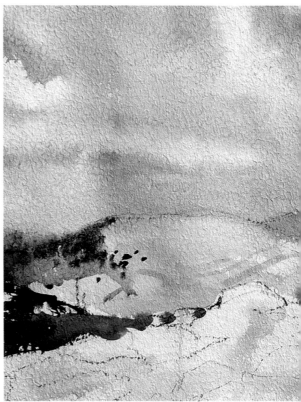

1 The pencil drawing is visible below the sky, which I have painted before touching any other part of the watercolor. The drawing depicts the rocks of the landscape. The idea is to delineate the entire mass of the terrain.

2 The central band of the landscape is almost finished. I want to call attention to the manner of working the hill of the background, a manner that we have already seen in some previous demonstrations. It deals with a very soft gray tone over which I will paint the thickets and grasses. This first grayish layer gives proportion to the hill, and it is important that it be of a very clear tone so that later there might not be problems in placing the superficial details. The sides of the composition constitute the lower thickets painted with a blend of green and Burnt Sienna, resulting in a subdued tone that brings out the grayishness of the theme.

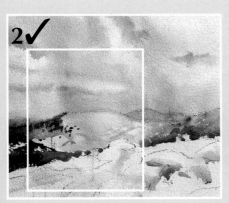

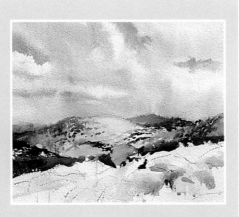

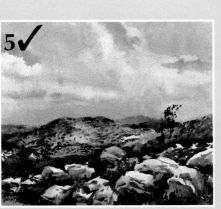

■ THE PROCEDURE

One of the keys of this watercolor has been its emphasis of rocks on a bare landscape. The color is a cold gray, which is the color of the rocks. Once the range is decided, it has been easy to elaborate the lights and shadows of these masses. The range has been composed of blues, greens and sienna. With these colors, I have worked to establish the rocks and also the hills of the background as my main points of interest.

STEP-BY-STEP

3 I am at work painting the rocks. It is based on saving the whites so that the rocks are a whitish color. They don't have to be very precise and sharply outlined. To the contrary, the technique is to shade and give mass to some of the forms whose own color is the white of the paper. What is important are the grays and the blending of these grays with the white. The edges of the rocks are smooth, neat objects. They are more abstract, in which the character of the rocks — furrows, irregularities — monopolizes their position.

4 The entire work is very advanced. The watercolor is now very rich in detail. We see now the result of the work on the hill in the background. The distribution of the thickets follows a moving rhythm that reinforces the mass of the hill. The thickets are small details. They need not be of the same color. In their lower part there are much darker tones and in the upper part, they have a much grayer tone.

STEP-BY-STEP

5 In the finished watercolor we see that the rocks have remained fairly individualized, almost to the extent that we can count them. Each one of them has its own character and is treated with attention to all the accidents and irregularities. We can see also that none of the rocks responds to a clear geometric pattern, but all contain angles and tend to stand out in their own right. I have hidden much of the ground with the final emphasis of the whiteness of the stones. This darkening does not outline them nor isolate them but is visually founded in their bluish shadows. The chromatic range is very reduced but has a special luminosity that is due to the abundance of whites and very bright tones in contrast with the almost black tones.

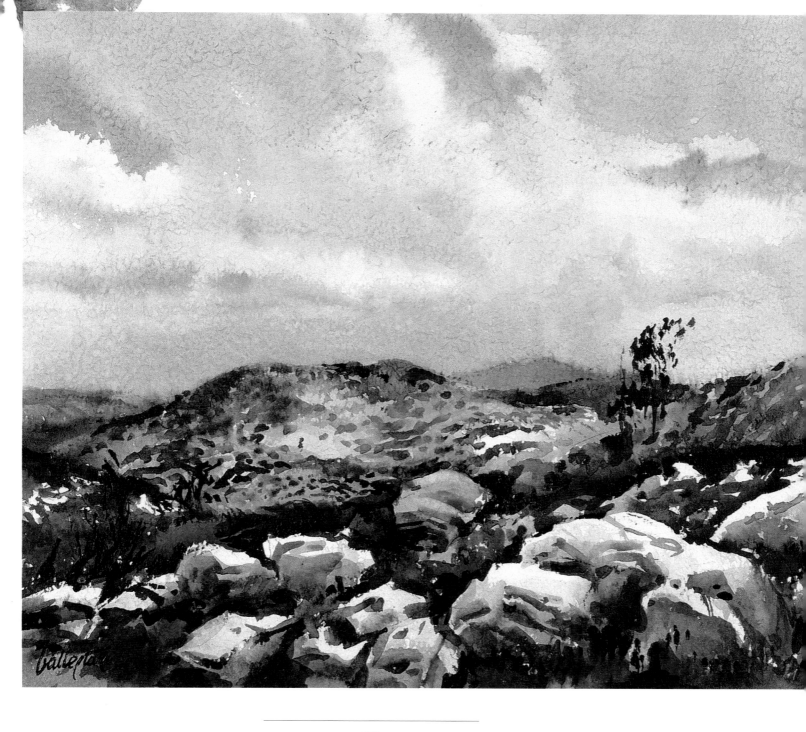

STEP-BY-STEP

The Study of a Tree

The demonstration on these pages is an example of how a painting of trees in watercolor was accomplished. Since our subject is a tree, I have isolated one from the cluster of them that I saw in the countryside. It is worth the trouble to study trees thoroughly to get the characteristics of their form. Trees are organic forms that have their own rhythm. As painters, we have to know what determines the anatomy of a tree with respect to the trunk, the thickness, the leaves, etc. For this step-by-step progression, I have chosen as my model a beautiful pine.

■ *THE PROCEDURE*

I have always followed this procedure in watercolor: drawing, first washes, general statements, and final touches. In the drawing I have been able to capture the movement that is distinctive in that particular tree. In the application of color I have worked small, sometimes miniscule, paint strokes to give a characteristic texture to the trunk and the points of needles in the treetops. The differences of tone in the treetop has been placed thanks to distinct intensities of a same green obscured by Burnt Sienna in the shadiest zones. The whole treetop is completed with small sized strokes that have been enriched by the small strokes of the leaves.

1 The pencil drawing sets the pattern for the texturing that will follow. We see that the trunk is not straight and rigid but presents a light movement toward the left before opening into the fan-shaped branches. These branches do not leave the trunk straight but take a light curve toward the outside as they rise. The mass of the treetop can be planned through an oval flattened on the sides that contains smaller ovals in its interior. These forms are found in the model. You have to study these anatomies carefully, for while many may say a tree is a tree, each tree is indeed individual and distinct.

■ *HELPFUL HINT:*

Certain species, like pines, olive trees, poplars, beech trees, etc., have marvelous shapes that make them suitable to include in paintings.

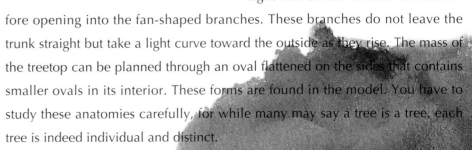

STEP-BY-STEP

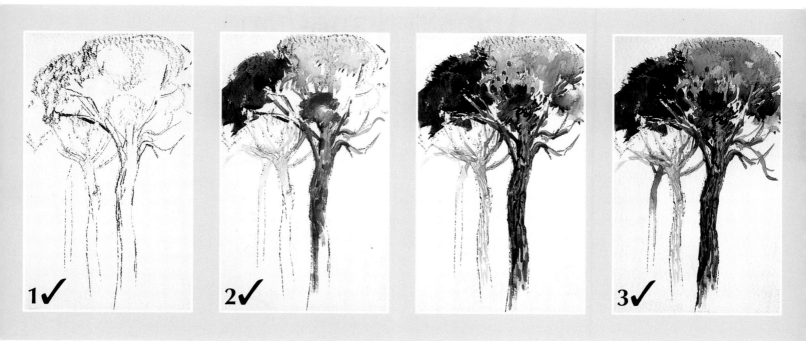

1 ✔ 2 ✔ 3 ✔

2 In the colors of the trunk, I alternate reds with Burnt Sienna. I add blue and gray to the mixture. With this superimposition of different tones, I try to reconstruct the texture of the bark. As I wrote earlier, it's important to be able to paint a portrait of your model—the tree. Once the structural problem has been solved, you have to study and look for forms to represent the characteristic surface of the tree in order to set it apart from the others.

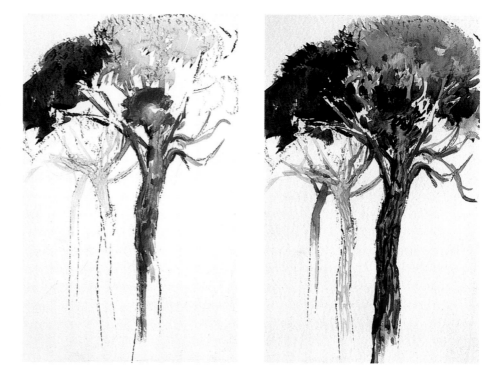

3 Up at the treetop, I have put in brief paint strokes in opposition to much wider strokes to promote a certain impression of movement. This is very important when we are representing trees and plants in general. Plants, leaves and branches are mobile; for this movement to be noted in the watercolor, it is necessary to get rid of the rigidity and close the form on all sides as if it were a solid and heavy mass. Through this same motif I have left some of the branches half done, so that they relate with the background. This is a sufficiently detailed study of a tree that can be repeated with different species, with dry trees, with trees in bloom, and so on.

A Spring Landscape

*T*hroughout the previous demonstrations, we have seen landscapes that could be examples of the themes of spring. It is not my intention to make this landscape one that is typical of spring. I only want it to be a credible watercolor that follows the rules that the medium demands of it. I intentionally set out to paint this landscape in a light rain, wanting to capture the vegetation in a freshness that makes it even more substantial. The humidity is there, making the poppies all the more lively as they jump out of the meadow to exhibit a beautiful display of color.

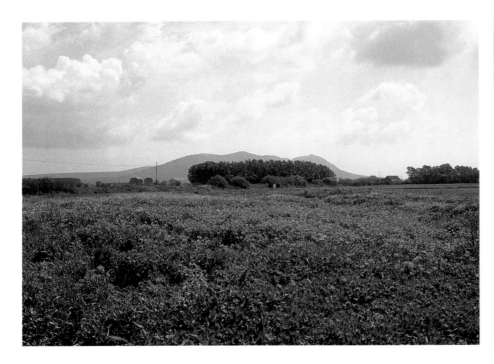

■ HELPFUL HINT:

Excess in the color mixtures tends to capture the colors in a solid, dirty way. Blended greens with a bit of yellow, clean rose colors, and light grays are colors that work well with the spring landscapes.

1 Truly, little drawing is needed as preparation for this landscape since the flowers are massed in with one shape of solid color. The unique thing that needs to be drawn, apart from the height of the horizon and the backgrounds, is the general direction of the masses of grasses and flowers, a direction that denotes a certain perspective or a diagonal that

STEP-BY-STEP

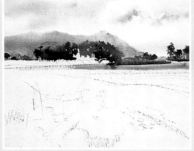
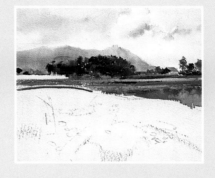
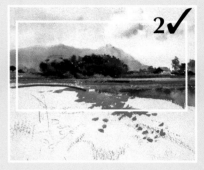

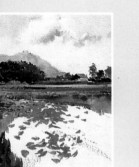
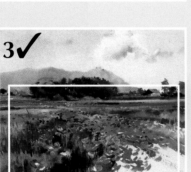
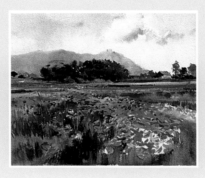
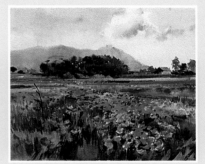

■ THE PROCEDURE

From the beginning of the work I have kept in mind the red of the poppies. While I worked on the washes of the sky or the wooded area of the background, I was mentally calculating the chromatic effect that I could get with these very intense reds. For this reason I have saturated the greens and have given them the total variety possible, because I knew that the reds were to introduce a beautiful chromatic tension. The rendering of the flowers had me occupied for a good period of time, and although they appear very much as one and in a continuous coloration, I didn't want an area that was too sparse in color; I wanted the flowers to be seen as loose and in movement, not a homogeneous mass pasted over most of the foreground.

merely suggests this perspective. The treatment of the sky is pure spring. I want to express its freshness, humidity and luminosity to represent so many skies that we see on spring days. I did the clouds with a great amount of water, leaving the areas white to later mix with the shadows.

STEP-BY-STEP

2 The mass of flowers farthest away, those that fall under the boughs of the trees, is a straight line of Cadmium Red. Now I will paint the flowers that are closest. At this time, it is important to note the distribution of the flowers over the field so as not to make them look artificial. The secret is in observing the general movement of these flowers and repeating this movement with my brush in a free manner. If you get too tight with the paint, you will lose the spontaneity that you're trying to capture.

3 The flowers that in the previous stage were floating on the white of the paper, now have received their grassy beds. The rendering of the grasses is delicate; it makes me leave small dots of the flowers. Some watercolorists would have used liquid frisket at this point. The frisket is a rubber cement kind of material that you use to coat small details in a painting, then you paint over this coat. When the area has dried, you remove the frisket and everything under this protective coat remains untouched by the color that was painted over the area. This saves you the trouble of painting around, and up, to small objects that you don't want painted, such as birds in the sky, details on houses and, in this case, the individual poppies in the foreground of the painting.

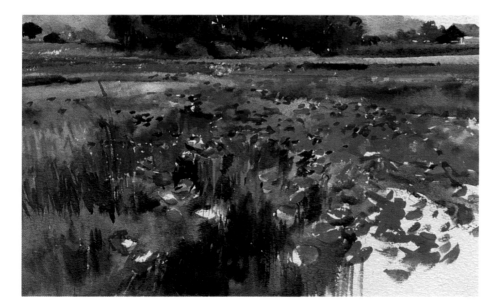

STEP-BY-STEP

4 In the finished painting, I have blended the largest poppies, bringing up their petals with their dark centers. Throughout the elaboration of this watercolor, I have tried to give the greens a certain lightness and freshness to give justice to springtime and a rainy landscape. I have introduced some emerald greens (over at the left) which are bright and decorative. Used wisely, it gives good results. I believe I have a successful watercolor painting here.

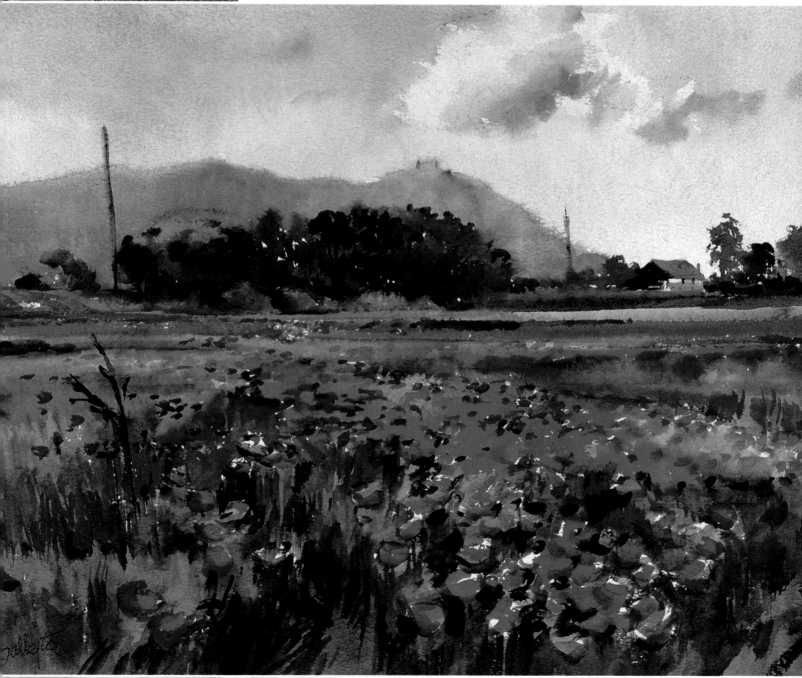

STEP-BY-STEP

Autumn Landscape

ow we are in the season of autumn. The day is calm and silent, a little melancholy, typical of this season, for with the coming of autumn, we know that winter is not far behind. This particular autumn was not one aflame with the customary leaves of reds, yellows and oranges. When I approached my painting's location, the leaves had already fallen from the trees, leaving the bare branches for a linear drawing kind of treatment. The landscape is serene and soft; the humidity of the environment envelops the horizon in a light haze, diffusing the colors and forms.

■ **HELPFUL HINT:**

Again we go back to the painter's problem of humidity in the landscape. Humidity corresponds to a work based in watercolors and washes, but it's far better under the control of the watercolorist. It is necessary to have dry areas over which the paint strokes will appear.

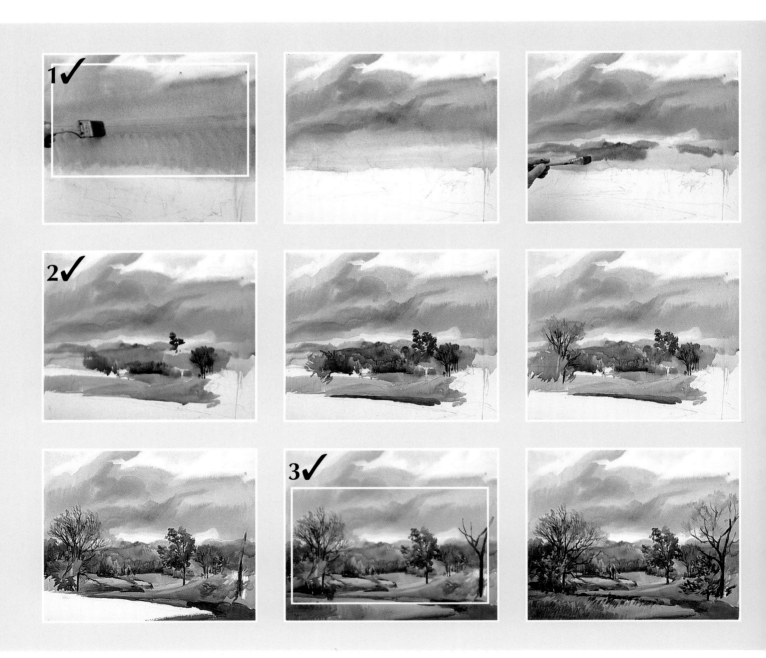

STEP-BY-STEP

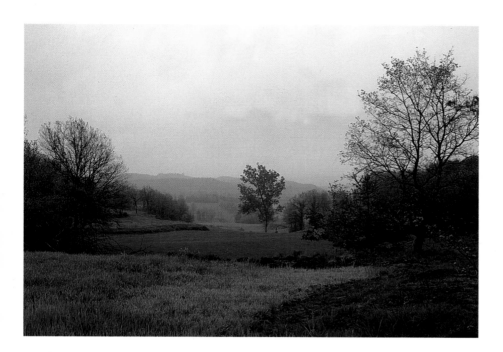

1 This landscape makes use of a great space for the sky, which is cloudy and a little leaden. This effect should be treated with a great deal of water. For this, I use an extra wide brush to put in the first wash, wetting the paper and extending the wash in all directions for the entire surface of the sky. In the upper part of the clouds, I have left some areas in white.

■ *THE PROCEDURE*

I always begin all of my watercolors at the top of the paper, working my way down. In this case, I have done the sky in a dramatic fashion, because I wanted to make a sky dense and rich in tones with many grays and with an abundance of cloud movement. Using the wide brush, I extend the color and construct the form of the clouds. This painting has become a soft statement toward the farthest backgrounds. With toned-down colors (gray greens) I gently colored the paper. Then, with a narrower brush, I put in the dry branches that rise through the top of the horizon until they become visible against the gray sky.

STEP-BY-STEP

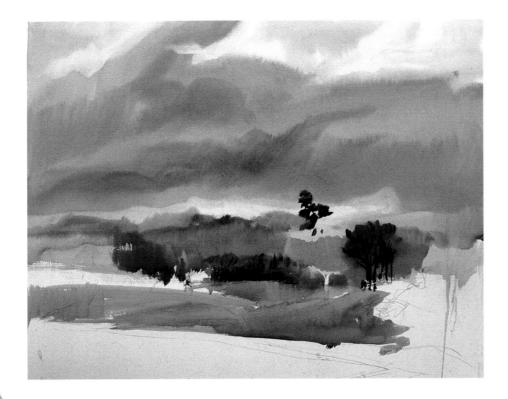

2 The area that's under the sky corresponds to the mountains that are seen in the distance. I work on this now. For the watercolorist, in landscapes such as these—gray and a little misty—the color of the mountains in the distance should pertain more to the sky than to the earth, which is tenuous and blue. I work with a blue-gray color. The outline of these mountains shouldn't be very sharp; it is necessary to blend them partially with the background.

3 In my effort to recreate a truly humid landscape, I continued working with a lot of water. All the visible colors now form an area of multicolor wash, as if the clouds have come down to muddy their tones. This degree of water in the treatment of the color is setting the general tone of the landscape: grayish and silent. While I work on the greens, I look for the variety of bright and dark tone values that I will use.

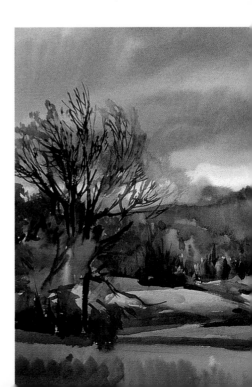

STEP-BY-STEP

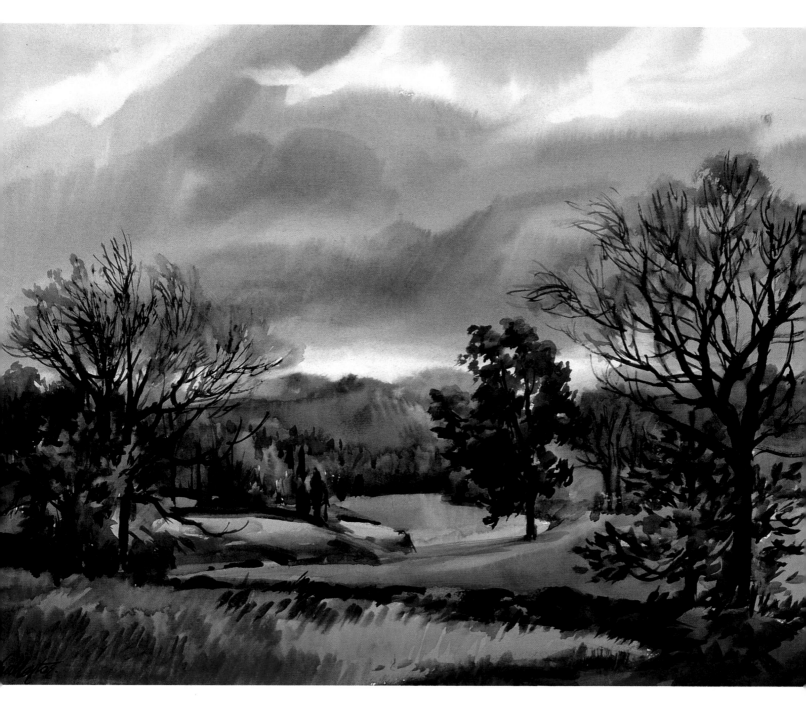

4 I have finished the painting and feel good about it. Following the same damp theme, I have covered the entire sheet of paper and have helped the composition with the curve of the road. You can appreciate the predominance of the contrasts of tone within the same range of color. The trees are now the darkest tones; on the right, their branches are outlined against the sky, creating the most intense contrast of the watercolor. The order of the layers is very clear, for you can look deeply into the landscape. The red road introduces a necessary warmth to all that green. It's obvious in this painting that what I had just painted was surely the last touches of autumn.

THE SKIES

The Light of the Landscape

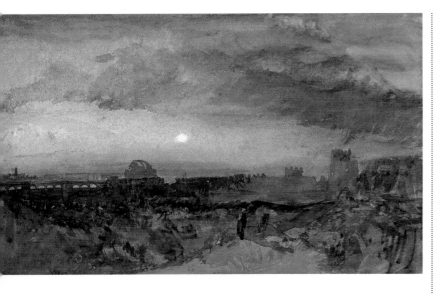

THE IMPORTANCE OF THE SKIES

The many different looks of skies have fascinated painters during every period of history. The series of studies of skies and clouds painted by the 19th century English artist, John Constable, are famous. Constable observed and painted endlessly the clouds at different hours of the day and at various times of the year, applying all his technique and talent to a literal interpretation of these important landscape elements.

For Constable, the skies were the key to the landscape—a key understood in its significance as a fundamental component. Relying on the chromatic and luminous tone of the sky, the landscape artist uses it to dominate his work.

To Alfred Sisley, the French Impressionist painter, the sky was a very important part of the work: "I always begin with the sky; the sky is not a simple wash in the background, a brilliant abyss. The sky is brother of the ground; and it is composed of planes as the earth. It forms part of the general rhythm of the work." For many watercolorists, the sky is truly a landscape in itself.

J.M.W. Turner, The Aqueduct of Claudio. Core Gallery, London. In the late afternoon, the position of the sun was one of the sensitive themes for romantic watercolorists. At twilight, the entire panorama was monumental and atmospheric.

Joaquin Sorolla, Storm. Sorolla Museum, Madrid. A dramatic sky obtained through contrast of color.

SKIES AND WATERCOLOR PAINTING

There are skies and there are skies—cloudless, smooth that are easily painted in a simple wash, keeping in mind the unique convenience of clarifying the color in the lowest part of the horizon. There are clear skies with soft pieces of clouds that seem to be made of cotton; they are painted easily, absorbing color and opening the white of the clouds with a

William Russell Flint. A Meander Along the Seine. Private collection. The sky dominates the space of this landscape. The entire terrain is moved by the play of light that is enhanced by the clouds. (Below left)

Claude Monet, The Sun over the Seine. Philadelphia Museum of Art. Monet was a maestro of the light of the landscape; he demonstrated a great talent in how this luminous moment was represented.

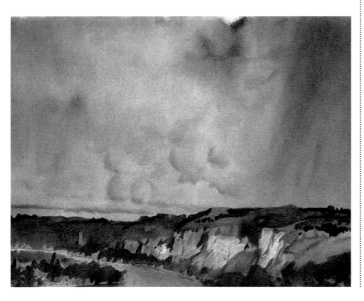

The splendid luminosity of this Ballestar watercolor appears in the great cloudy masses that animate the surface of the sky. The light and clouds have a curious relationship; they depend in a way on a luminous vista that would be lacking if the sky were cloudless.

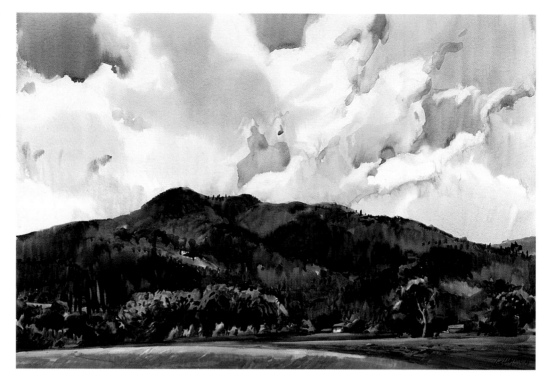

clean, dry brush. There are very wide skies whose whites need to be exposed with the help of a sponge.

There are also skies like those painted by Constable, with low horizons, or skies with cumulus clouds, with brilliant lights and soft shadows, combining at times with tempestuous clouds of dark gray color.

Georgia O'Keefe, Afternoon Star. Yale University Art Gallery, New Haven. The fascination through the luminous effects of the sky provoked this artist to make a very personal interpretation of the twilight sky.

THE COLORS OF THE SKY

Depending on the time of the year, the hour of the day and a thousand other factors, the color of the sky changes greatly. From the pure blue of a clear day to the complex mauves and reds of twilight and passing through to the Yellow Ochres of a cloudy late day in summer, the colors of the sky are the most changing ones of the landscape. The painter is offered a unique opportunity to be inventive. The phenomenon of the sky challenges fertile imaginations.

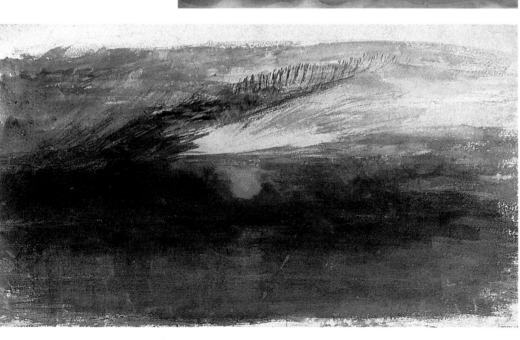

J.M.W. Turner, Between the Shadowed Clouds. Tate Gallery, London. The darkness of the clouds is an excellent screen over which the fiery red of the sun stands out.

Clouds

CLOUDS AND MASS

Clouds are a component of mass that are more imposing than any other solid object of the landscape. For that reason, they have every right to dominate an entire landscape. This occurs on those occasions that the painter sets the theme by the attraction of moving clouds. These indications are

The cloudy sky is, in itself, a landscape with its boundaries, its distances, its superimpositions of space and its own mass.

indispensable in a cloudy spectacle that features the mass.

Like all large areas that appear in a space, the clouds vary in size according to their distance, but to determine this distance, it is a bit more difficult in the sky than on the land, where we have points of reference. Calculating the distances in the case of clouds is an operation that is not easy, because the form of the clouds changes constantly during a painting session.

Aerial perspective (the effect of softening the color due to distance) is accentuated in foggy landscapes, such as at the dawn, where the landscape is concrete only in the foreground.

THE TECHNIQUE OF THE CLOUDS

A sky with clouds cannot be improvised, cannot be painted without a preliminary, well constructed drawing. This delineation explains where and how a form begins and where and how it ends. It is necessary to study the location of the sun and the direction of this light source, observing that the blue color of the sky, dark or bright, makes the white illumination of the clouds stand out, remaining as background in the sky.

Each type of cloud requires a variety of techniques that can be achieved from working damp, working dry, saving whites, etc. A sky with well profiled clouds and precise mass calls for a treatment on dry parts of paper with super-

impositions of color, with transparencies in the shadows and with an abundance of whites to insure that they are as clean as possible. A cloudy gray sky asks for a treatment over dampness, rich in water, in which the paint strokes lose unity and blend one with the other and in which the artist can work calmly without fear that the colors will dry too soon and ruin the whole effect.

The painting of the skies can very well monopolize the attention of the painter and become the protagonist of the landscape. In the watercolor that's shown below at the right, the sky has taken that starring role, the horizon line has lowered and almost the entire surface of the paper is used to express the forms of the clouds that are moved by the wind.

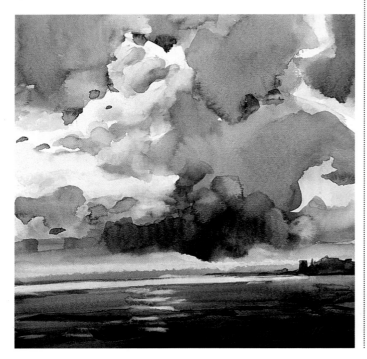

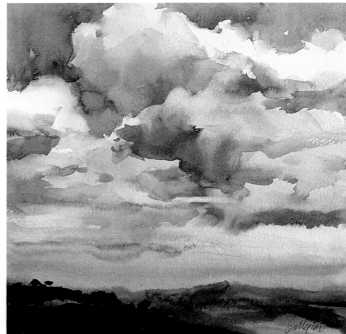

Situating the horizon very low is a form of accentuating the importance of the sky and the clouds. In this work, the horizon suggests that the point of view has been a well-planned vision from above.

STUDIES OF THE CLOUDS

Working on studies and color sketches is always advisable. It's mostly true for those who practice watercolor landscape and for the landscape artist who wants to practice with clouds and cloud effects. The rendering of clouds requires rapid and direct work to picture the fleeing forms. You can develop the speed needed by doing many sketches from nature. You don't need to indicate the horizon of the landscape nor design a composition; it is enough to do finger exercises with an agility over the paper so that your eye and your hand can work together to capture the element of the passing clouds. Also from constantly sketching, you can get the impetus for a more developed work on location in which the clouds are the central motif.

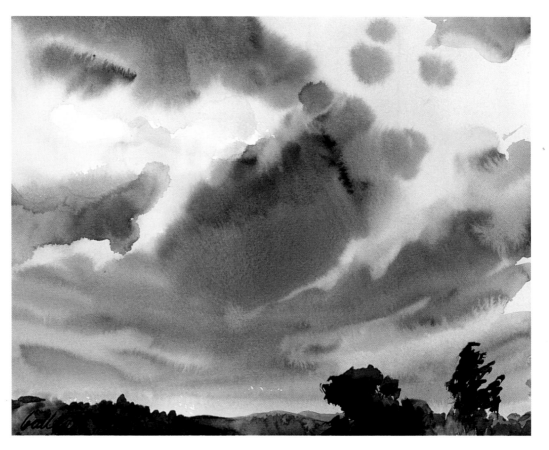

Ferdinand Hodler, Eiger, the Monch and the Jungfrau at Moonlight. Private collection. At first sight, the clarity of this landscape does not correspond with a nocturnal vision, but there is no doubt that, thanks to the insistence of the strange light in the sky, the artist has been able to present the light of the moon in a landscape of the high mountains of the painting's title.

In all representations of clouds it is fundamental to watch the direction that they take as they are moved by the wind. This direction not only contributes to give validity to the work but also adds to its particular importance. Observe in this work how the clouds move diagonally in a somewhat opposite direction from the horizon of the landscape.

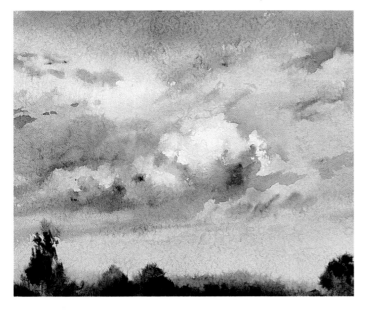

The fusion of clouds is a good reason for practicing the work of dampness over dampness in which the forms fuse one into the other, thus losing their profiles.

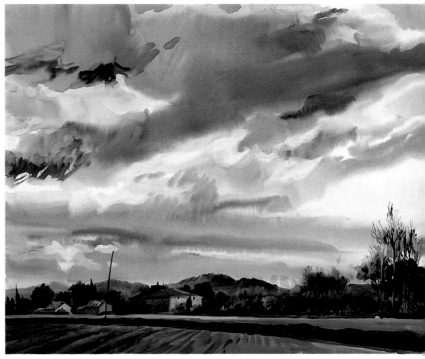

Snow

SNOW, IDEAL FOR WATERCOLORS

Canvas or any other support for an oil painting is just that—a support upon which layers of paint are applied. On the other hand, the paper used for a watercolor painting *becomes* the painting. The white of the paper shows the transparent applications of color, thus giving watercolors a luminosity that's difficult to achieve when colors are mixed with opaque white paint. The watercolorist buys his white by the sheet, the oil painter buys white by the pound. The watercolorist takes advantage of this asset when painting fresh snow. While there have been many successful snow scenes painted with oil paint, the luminosity that a watercolorist can get is not one of oil paint's strong points.

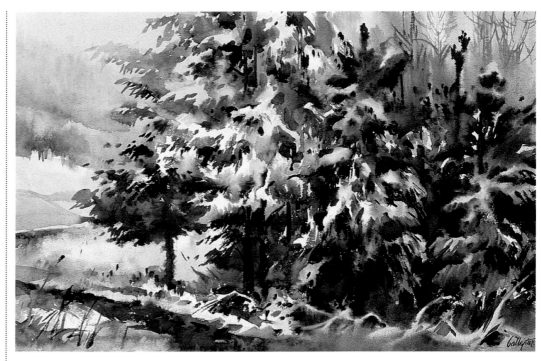

In this watercolor one can see the technical process it takes to render the effect of snow in the background of the landscape. The work is done on very damp paper in which the color is extended and the edges become blurred. The control of dampness is essential to getting this effect.

In the above work the foreground occupies the major part of the paper and the snow only is represented as an abstract background against which the foreground is outlined. The range also plays an important role as the toned-down areas blur well due to working on damp paper.

SNOW AND WASHES

Snow in landscape is an excess of dampness that disperses the forms and grays the colors. To represent it correctly, the watercolorist should work over a very damp surface. The paper should be wet up first with a sponge and the artist has to work without letting it dry, dampening it again as necessary, so that the paint strokes lose the contours and fuse into the general tone.

But a landscape with snow that's been painted exclusively on dampness has its inconveniences. If the painter is not experienced, the result can be one of a runny mess. The solution is to control the water in a way that it doesn't run too much, first, because of its position that's caused by the inclined level of the paper. And,

Ferdinand Hodler, Mountain Ranges Among the Clouds. Private collection. Snow in the mountains is a popular theme in realistic as well as abstract watercolor representations.

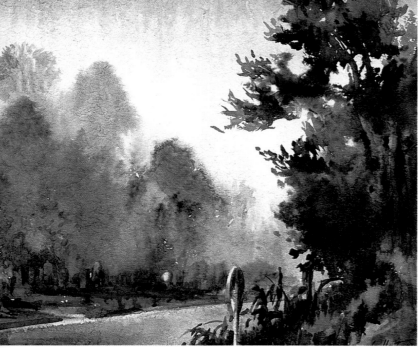

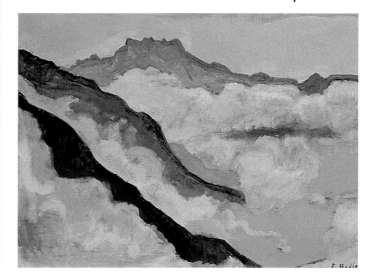

second, by adding some details on dry portions of paper. These details will be in the area of drawing. For example: while the general tone of a tree can be softened with the background, its branches can stand out sharply, drawing them with the tip of the brush over dry paper.

Including small details over the muddy expanse (which are those that give value and expression to the snowy atmosphere) is a contrast that is found in real snowy landscapes and the painter should have that in mind when applying it to the work. These details tend to be found in the foreground, which helps to create the visual sensation of having the landscape foreground truly up front.

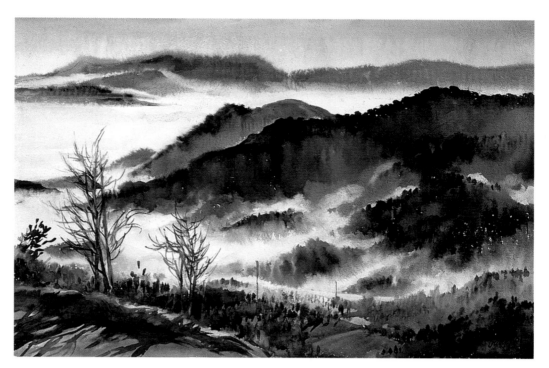

This view of a landscape of low clouds, seen from on high, gives a new feeling to the theme. The mountains appear to be islands that float in the whiteness of the clouds.

J.M.W. Turner, Lousanne and the Ginebra Lake. Private collection. In the picture at far right, we see another theme of fog and the mountains, this time interpreted in a grand way with respect for the space. The mist contributes to give spaciousness to the panorama.

Giving free rein to the movement of water over the paper is a good idea; it gives you effects that are impossible to get if worked rigidly and in a controlled manner.

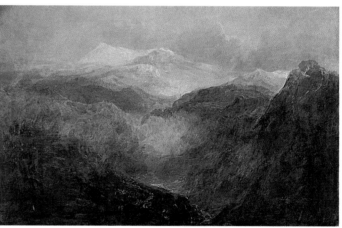

FOG

Fog is a typical phenomenon in winter mornings but can crop up at other times of the year. The representation of fog is a particular case of the pictorial problem of painting snow but that only affects the final planes of the landscape. When working over a humid surface, for the most part, the sky and the area of the horizon are painted at times in conditions where they are chromatically reduced.

Fog in the mountains, seen from above, is a spectacular theme that all watercolorists have dealt with many times. It is a romantically suggestive theme that permits play with forms and colors that appear and disappear.

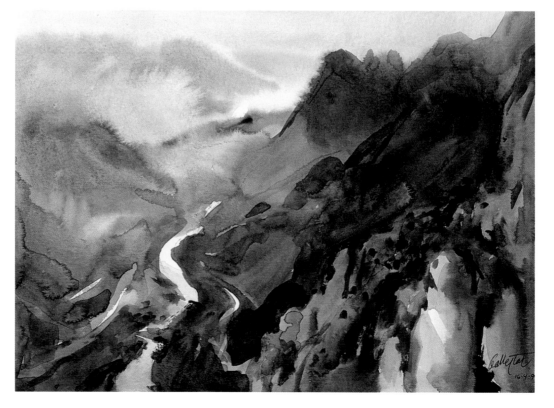

STEP-BY-STEP

Luminous Sky on a Windy Day

his watercolor was painted in spring on a fairly windy day. The wind is not a good friend to the landscape painter; it can be a veritable pain in the neck, with nothing to show for your effort but a bad painting. Fortunately for me, this day, the wind, though breezy, did not present a problem. Besides, one of the advantages of windy conditions is that it's ideal for painting skies. Luminosity of the air and the clouds, and the subtle changes of light all added to the spirit of the work. Painting only clouds can be a good exercise and can produce works of great interest, but since clouds are major parts of the landscape they have to be interpreted as vital elements in the composition of land and sky. Furthermore, the grandness of the sky is best appreciated when we compare it with the earth.

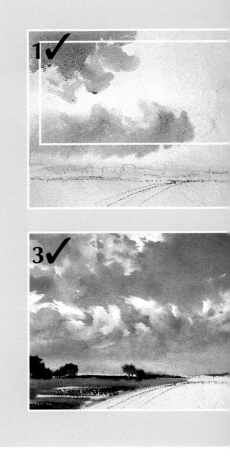

■ *THE PROCEDURE*

Before settling on the clouds on a day in which the wind blows, it is fundamental to have a general scheme for the sky. It is not a linear scheme since the contours change constantly, but a scheme of great masses through which one can interpret and represent the distribution of the clouds. This has been my principal preoccupation: getting to summarize the movement of the clouds through blotches of color to which later I will superimpose the blues of the sky, leaving the clouds white.

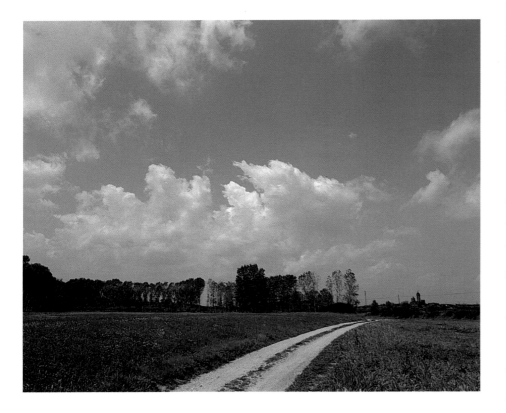

■ **_HELPFUL HINT:_**

Getting luminosity in the sky is a problem of extending my washes to let the white of the paper be transparent. Opposing this with the darkest parts of the clouds can get truly suitable effects of clear light.

STEP-BY-STEP

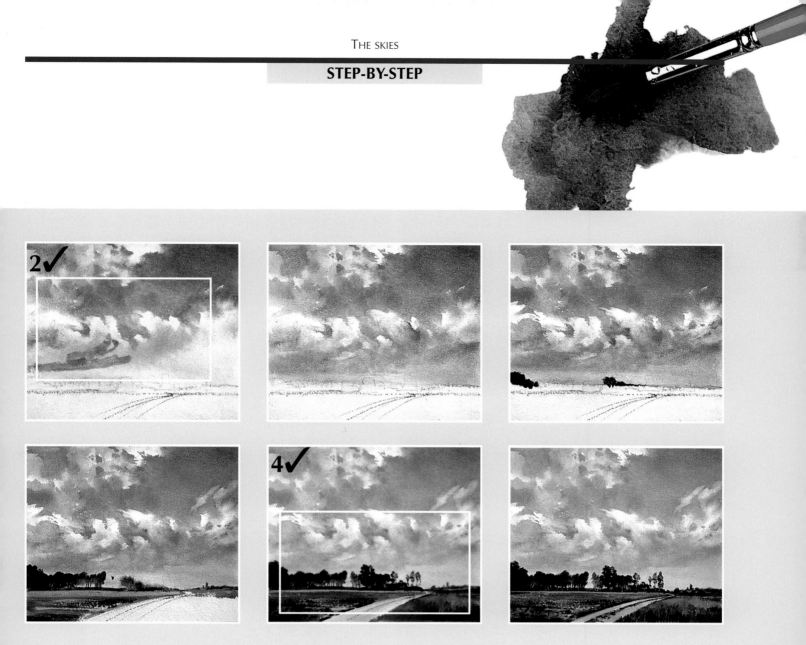

1 A large wash is put in all areas of the sky. The wash has important contrasts of value. We see two great shaded areas that suggest a great cloudy mass. This can seem to be contradictory with the appearance of the sky that I hope to paint, but it isn't; it deals simply with a first drawing, to block in the small masses of the clouds.

2 Now comes the wind; we arrive at the moment of breaking up the masses in strips of clouds. I do this by introducing blue and invading the whites left before and outlining the form of the clouds. The paper should be damp to soften the outlines; in the upper part we see fusions of blue with the gray of the clouds, as it should be. The observation of the model is essential. Once we begin to paint, we can't pay attention to the changes of the clouds.

STEP-BY-STEP

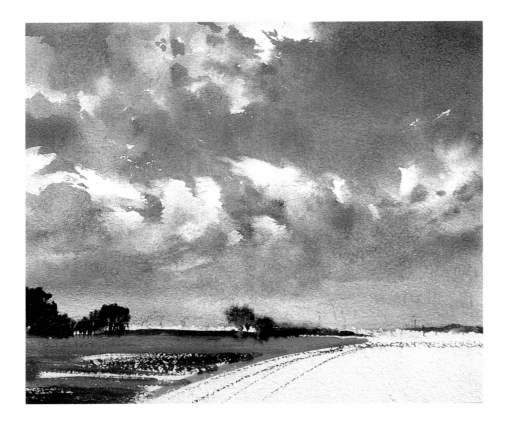

3 As I begin to paint the land, I want to get fresh and luminous tones to harmonize with the day. This can be achieved through clear greens in contrast with very dark colors. These darks are the band of the horizon and the trees that arise from it. I have respected the line that escapes toward the background and now the watercolor begins to present a clear sensation. We see how advanced the work of the sky is, how I stroked the clouds in a determined direction: toward the right and in a curve, starting a cloud whirl. The luminosity I get is my reward.

4 Here we see the landscape which is almost finished. Look at the trees, key elements of this landscape. The trees are different one from the other, but at the same time they are trees of very small size. Having added to their size a bit, the sky may have lost some of its bigness because the objects of the landscape are more important than the space that they occupy. The road now heads off toward the background.

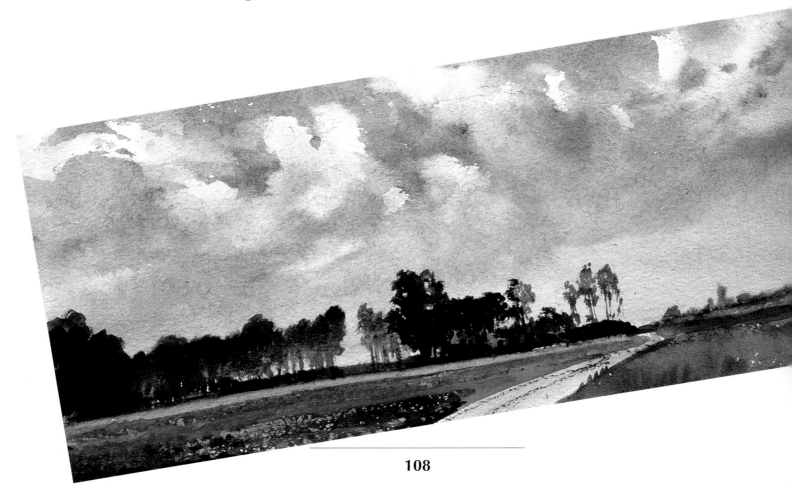

STEP-BY-STEP

5 The final result. The band of trees is now much darker. The meadow displays flowers that give life to fresh green fields that are rich in blends. The perspective of the road is completely done and we can follow it to the end, right into the horizon. While the crowning achievement in this demonstration may be the clouds and the sky, the landscape is substantial overall and is one in which sizes and distances have been thought out and well executed.

STEP-BY-STEP

Fog in a Dry Landscape

og is humid; it is water. For this reason fog and water seem to be made for each other. A fusion of colors over a damp background in which the shapes blur and get soft, give it an effect of fog. Therefore, to paint a dry landscape is, in principle, a question of the dampness of the paper, along with colors that have to be chromatically reduced. In this demonstration, I use blue, Burnt Sienna and green, three colors that give me an unlimited range of grays. If we consider that the important color in this landscape is the white of the paper, the palette for this exercise is complete. In regard to the comfort when painting nature, fog and snow make a good combination.

1 In spite of the fog, the pencil drawing is quite detailed. This landscape is full of movement and broken up into distinct stages. I proceed to put together the elements of the landscape with simple lines, like the curves to the left, or the way of centering and proportioning the trees through the contour of the branches and the use of one or two strokes to situate the trunk. I don't leave too much space for the sky. In this landscape there isn't much of it because the fog hides it.

STEP-BY-STEP

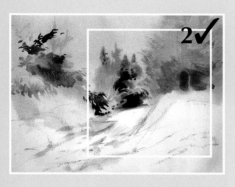
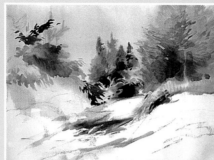
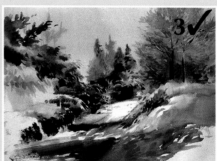

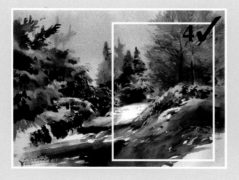
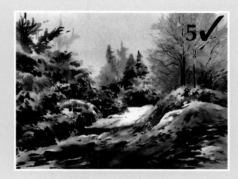

■ THE PROCEDURE

It all began as a wash without color. I used only water so that the paper may be the fog that diffuses the landscape. The paper may also work as the snow that partially covers the forms. The process of this watercolor has been, in effect, almost a work in black and white. What is really important in it are the grays. I have taken care of the quality of these grays, making them more green or more blue, toning them toward a silvery mixture. Working with grays always is agreeable because the water for modifying the tone and a light mix of another color is sufficient for enriching it. The representation of the snow has been laborious since the contrast between the white and the almost black of the shadows is very small and takes work.

2 I begin to paint after having brushed over the paper a wash of clear water, without addition of color. This wash will be the fog, the one for which the colors are fused and diffused. We can already see in the first applications of color: the tree on the right seems covered by a translucent layer. Upon painting it in a gray wash, the color has clarified and dissolved a little in the damp background and the strokes of the brush have created soft applications.

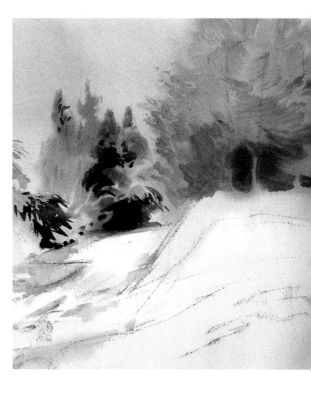

STEP-BY-STEP

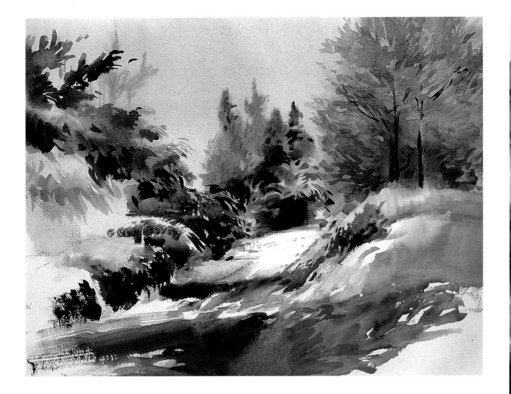

3 The fog of the background has visually sharpened the foreground, which I then recorded with intense and contrasting color. The transition between sharp and fuzzy should be gradual. The fallen snow over the branches of the trees should correspond to the white of the paper and not cover the branches too much. To solve this problem, I have to break up the strokes, making use of the sprinklings of color and intensifying the small shadows.

4 I now stop myself to give some thought to how I will treat the treetop on the right. The foundation of all of them is the initial wash over which I have applied a light gray wash. And this last wash, which is now dry, has small paint strokes and lines of a little more intense gray superimposed, hiding the lower part of the tree only enough for the mass to be evident. This successive contribution of colors and blends of gray in transparency, makes the tree seem to be dry and it takes on a beautiful silver quality.

STEP-BY-STEP

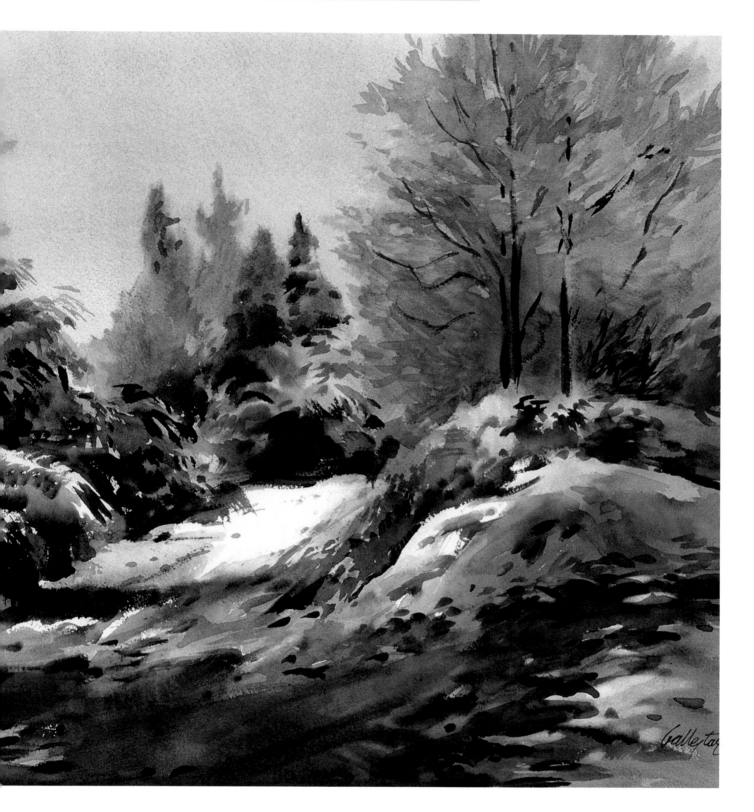

5 The watercolor is finished. I have taken special care in the drawing of the branches and the trunk of the tree on the right, making them appear and disappear between the leaves. The foreground is completely fixed in the composition, and the effect I wanted has been reached. The richness is obvious in that it has been done with the use of very few colors. The fog is present all over in the whiteness of the background; this is one of the keys of landscape with snow; it is not necessary to break the lightness of this white with mixes or shadows. I believe that the result is interesting, though the effect is cold damp and quiet. To tell the truth, it's not very pleasant painting outdoors on a day like this, but if the watercolor is successful, as I think this one is, it's easy to forget the discomfort of the cold day. Enjoy the experience of the painting...after all, that's really what's important.

WATER AND RAIN

In this watercolor, painted from the photograph of the landscape, you can feel the impact of a damp and rainy day. The puddles are large and by their shape and color, we can assume that at the moment of the photograph, it was raining quite hard.

The painting of the rainy land-scape doesn't necessarily have to represent intense cloudbursts; it can well limit itself to the effect of the rain over the entire land-scape and to the raindrops in the puddles of water.

REPRESENTING RAIN

In Asian art, especially in the Japanese style, we often find the theme of rain. Japanese painting, essentially linear renderings, favors line over color. Japanese artists represent rain through straight lines in a downward direction. In a watercolor that's painted by a western artist, tone dominates line. The result of painting as the Asians do, therefore, would look artificial and forced.

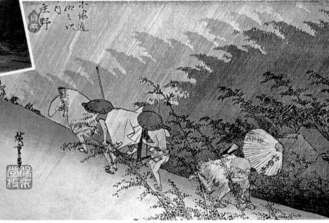

After a rain, there is a special quality in a landscape. This is an ideal time to paint nature, which is replete with clear light and a particular freshness in the colors of the motif.

Hiroshige, The Landscape of the Shono. National Museum, Tokyo. Japanese artists have a fondness for themes of rainy landscapes. With a style that's essentially linear, they can permit themselves to represent the rain through fine diagonal lines.

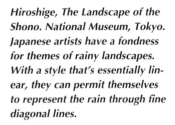

EFFECTS OF RAIN

We find effects of the rain in the movement of drops in the puddles, in the wet appearance of the atmosphere and in a bright characteristic of light surfaces. But these always seem to work in concert.

In a watercolor of a rainy day, we can apply the techniques used for fog and mist. Mists obscure the peripheries of the landscape on a rainy day and are of the same type as morning fogs, except that their tonality tends to be colder, more blue.

The waves on the puddles, ponds, etc., are difficult to represent faithfully. They are tiny and changing, and, like all types of movement, impossible to directly copy. They can be suggested through a profusion of paint strokes or through small concentric circles. The brights over the smooth surfaces are the easiest to paint successfully.

Washes and fusions of color are the method of getting these brights. They appear because they give the sensation of reflecting other forms while losing part of their own color.

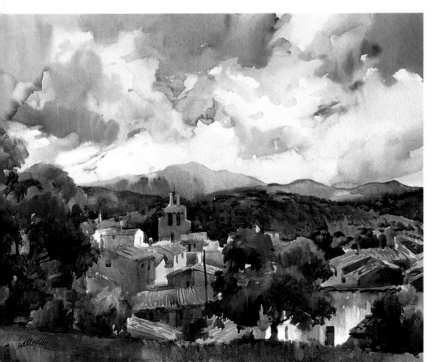

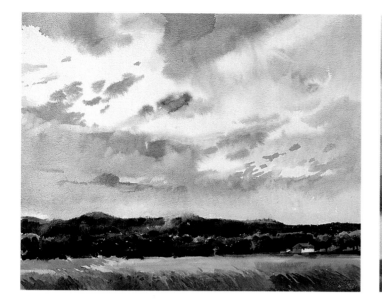

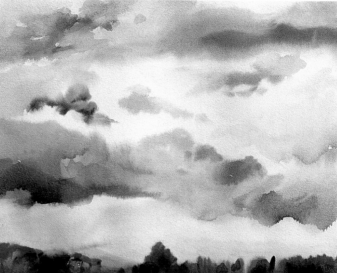

The quantity and variety of pictorial possibilities that rainy skies offer are well known by all experienced watercolorists. On rainy days, we look for mixtures, contrasts and a wealth of grays.

Organizing the rainy sky through bands of cloudy blotches makes for an interesting painting. Alternating values of bright and dark, apart from giving dramatic thrust to the plane of the sky, culminates in an effect that's profound and atmospheric.

RAIN AND LIGHT

Light on rainy days is a weak light without hard shadows, without intense light. The dark tones of the tree trunks and the brights of the leaves are indeed intense, but they are independent of shadow. This shadowing exists but the painter can disregard it. After the rain, it is seen clearly when the light has brightened and all is cleaner, fresher and more contrasted. At this moment, the greens take a special freshness and contrast. It is the general dampness that enhances the most pictorial values of the theme; it is a moment that's ideal for painting watercolor.

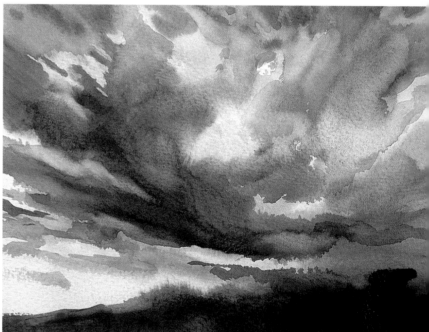

This watercolor is a magnificent interpretation of a cloudy sky. The work is an excellent example of a watercolor that can hold the drama and richness of the instant in which the sky displays its cloudy masses in a surprising and highly picturesque way.

Dirt roads flooded by rain make an excellent theme for the practice of watercolor. The rain tends to convert boring dirt roads into textures of fascinating interest.

Reflections

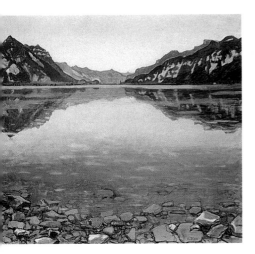

Ferdinand Hodler, Landscape of Lake Thun. Private collection. The artist combined the landscape's reflections in the background along with the transparency of the water in the foreground.

The reflections over the river's surface are of the rocks in the foreground of the composition by Ballestar.

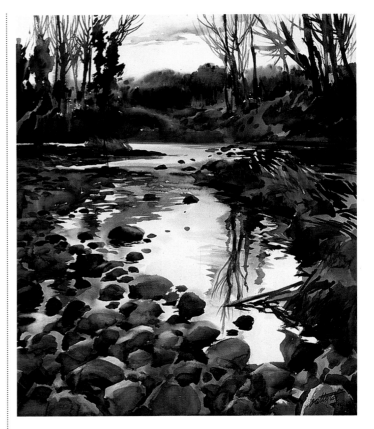

REFLECTIONS IN THE WATER

When painting a landscape, in the rain or afterwards, you have to be aware of the effect of the reflections in the wet surfaces. These areas reflect colors that are represented by the way in which these reflections appear. The water of a landscape scarcely can be conceived as color. It deals with a minor display of water, not of the sea or of other bodies of water such as rivers.

The color of water is a reflected color of the landscape. It's a clear color if it reflects the sky and dark if it reflects the riverbanks. But the color never is exactly the same. The puddles don't reflect the blue of the sky because the shallowness of the puddles' depths affects the color, making it grayer.

Tchao Kan, Travels by the River. Palace collections, Taiwan. In the painting shown at the right, the water is the result of a linear work in which the reflections are in the gentle flow of the river's current. The art of China always stands out in the delicate way they represented nature.

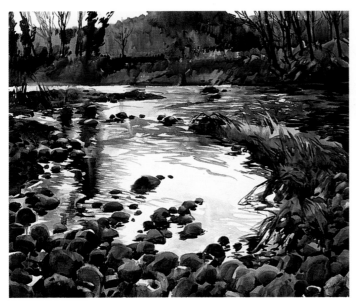

In a new version of the landscape pictured above on the right, the artist emphasizes the reflections and the mass of the stones. Both pictures possess a special chromatic harmony that makes the reflections stand out in contrast to the forms.

RIVERS AND LAKES

Rivers and lakes in landscapes are fountains of reflections. The trees on the shores repeat their profiles and the horizon from the banks are converted into mirrorlike images of the landscape. Many watercolorists like to look for these reflective bodies of water,

In the images below we can see how the questions of reflections is not simply a problem of literal representation but of artistic interpretation. Reflections in this landscape have been intensified to recreate the motion produced by the current.

Reflections also can create effects of distance, as this work demonstrates. The clarity of the foreground of the lake gives passage to the bank that is reflected in the water.

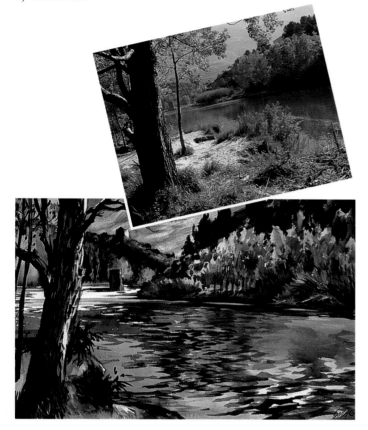

STATIC WATER AND MOVING WATER

The movement of the water is definitively influenced in reflections. The river's current reflects the forms and converts them into a crush of light and shadow that the painter chooses by observation and his ability with the brush. Paint strokes should be small and should go in a progression from dark to light as we move away from the banks, making them also more distant and more separate from us. The color also changes: the closest paint strokes to the light should be clearest and most transparent than those we applied close to the bank. It is a work based in the control of the water of the mixes and of the touch of the brush.

The quiet water of a lake composes itself as a mirror that returns the contours and some details but not the exact color (except in the case of a very sunny and bright day); it tends to be a lower tone with a gray tendency.

choosing a point of view that elevates it or makes it descend toward the lower part of the work. If the bank is elevated, the foreground remains strongly marked by the plane of the surface of the water with all its plays of clarity and transparency. In any case, the movements and the light bring life to the composition. In the case of rivers, the banks are snake-like and can be used to great advantage to inject additional animation into the composition.

The richness of this watercolor is due to a recreation of the reflections on the water of the river. Taking a point of view that starts from the foreground, the theme covers a new interest and the reflections become the star performers of the work.

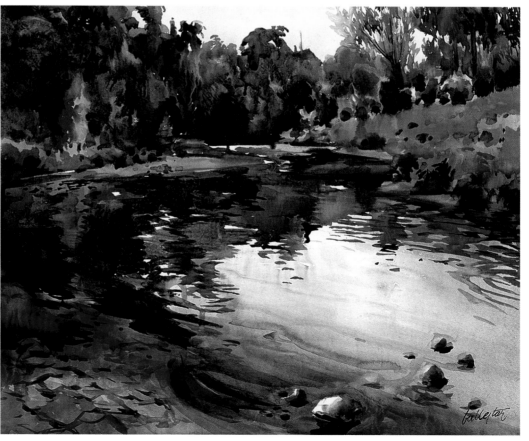

The Moisture of a Landscape

CLIMATE AND HUMIDITY

It isn't necessary that any water be visible for a landscape to be characterized as damp. The tone, the intensity of color and the look of the atmosphere can produce this sensation. Many landscape painters seek out damp themes to take advantage of the effects they can get with the medium, such as marshes, bogs, an especially leafy and shady corner, or the morning dew. These are favorite themes.

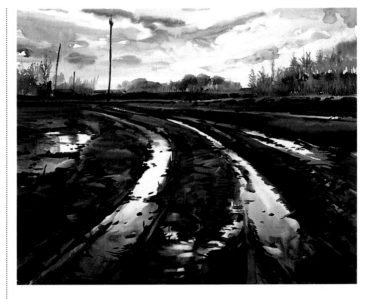

The humidity of a landscape shows a particular attention to its pictorial possibilities. As seen here, the wet ground, the mud, the tracks of the vehicles, become vital elements to the theme of this watercolor.

GRAYS AND GREENS

Greens and grays are the colors that best set the pace for a landscape's humid atmosphere. Grays that can be a result of mixtures of earthy browns and blues toned down with water are ideal for this atmospheric condition. A very rich gray works fine for getting distinct intensities and to work with in the backgrounds. Cold greens, blended with a little blue, also promote that sensation that is used in the description of the atmosphere, in details like a cloud of smoke, a mountainous background, etc.

Spring mornings are moments in which moisture on grass and flowers (moisture that's independent of rain) can be used for dramatic pictorial effects. The watercolor reproduced here was painted during one of those moments.

EN PLEIN AIR

During the late 19th century, when landscape painters still worked entirely in their studios, a group of painters began to paint directly in the light and atmosphere of the great outdoors. The French called them *pleinairistes*, the artists who were bold enough to paint *en plein air*. Today, that long ago phrase has been brought back into vogue, mostly as a term of affectation. Once these people started to paint in the open air, they were delighted to go out constantly, chiefly, though, in the mornings and late afternoons. Today's *plein air* painters still choose to adhere to this wise practice.

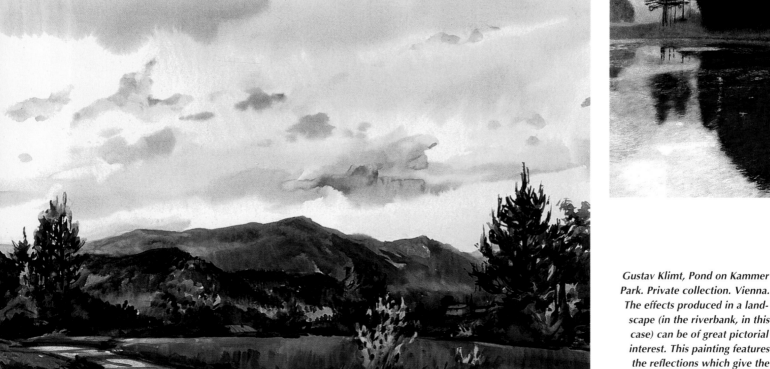

Gustav Klimt, Pond on Kammer Park. Private collection. Vienna. The effects produced in a landscape (in the riverbank, in this case) can be of great pictorial interest. This painting features the reflections which give the appearance of a humid setting.

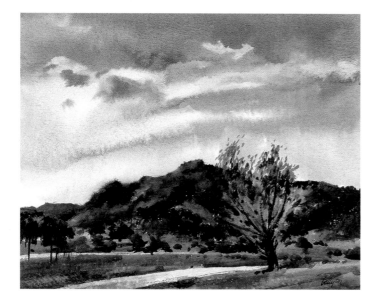

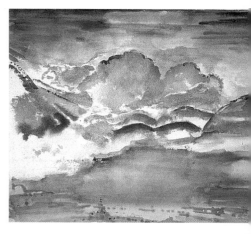

The contrasts between very humid areas of the watercolor and very dry areas are fundamental for the convincing look of this landscape.

Georgia O'Keefe, Star in the Afternoon. Yale University Gallery, New Haven. The effects of the late afternoon receive an interpretation in this work that's dominated by cloudy forms and intensity of color.

GRADUATING THE HUMIDITY

There is an ease with which moistures can be suggested in painting watercolor. This ease can be utilized by a technique that could be applied to all landscapes. For this, the maneuvers must be on the dry texture of the paper, applied in certain areas of the landscape, such as in the foreground where that texture can have a realistic significance.

Contrasts between dry and damp zones, between the technique of drybrush (that leaves a rough track on the paper, revealing the grain of its texture) and a great wash, are very important and leads to an interesting result.

John Singer Sargent, Fire in the Mountain. The Brooklyn Museum, New York. A brilliant example of the use of washes and moistures in the rendering of watercolor landscapes. In this work, a burning forest is represented through the abundance of washes and chromatic fusions over damp paper, in a manner that is normally used to represent clouds and damp effects.

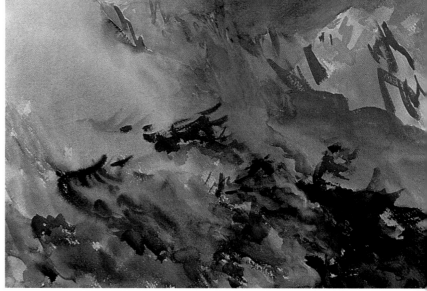

Damp over damp, the lights of the sky are totally natural. The watercolor needs also some precision in the contours that is achieved by working on a dry portion of the paper.

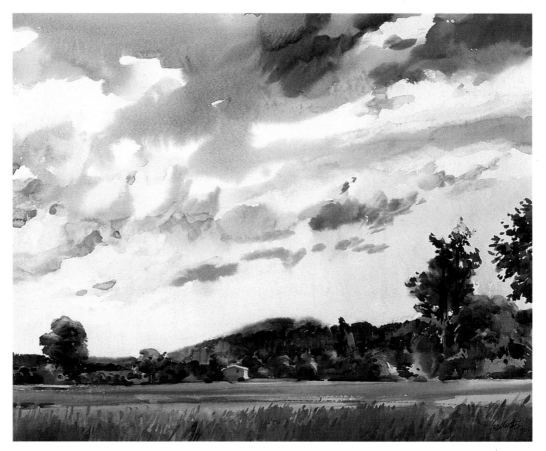

STEP-BY-STEP

Landscape in the Rain

n this demonstration, I want to arrive as closely as possible to a representation of rain. I chose a stormy day and armed with an umbrella, I place myself under the downpour. The noise of the rain lets me know that it is present, but it is something that the artist cannot portray with paint. From the start, surely, I reject any notion of drawing lines or using any other device to reproduce the water falling. I have to concentrate instead on the effect of muddiness that rain produces in the landscape, a very distinct effect from fog, although with similar results. Fog envelopes and softens; rain creates a screen that obscures form. Choosing a high horizon, I aimed to attain the presence of the mud and the puddles for the effect of falling drops of water.

■ THE PROCEDURE

The first strokes of color were very vague and general and I like to believe that already in them one can note that it is raining, precisely by the muddiness of the terrain. Every moment of the painting supported this effect. The color of the mud is complex because it contains many colors. It is an ideal color for experimenting with new colorations and for testing distinct effects.

1 I have chosen a point of view that is clear in the pencil drawing: a high horizon and a lot of space for the road. The structure of the landscape is put in with some straight lines that are rapidly drawn. The curve of the road is exaggerated. It isn't worth it to draw the puddles because they can be directly painted with color and paint strokes. The tree is sketched with very little detail.

STEP-BY-STEP

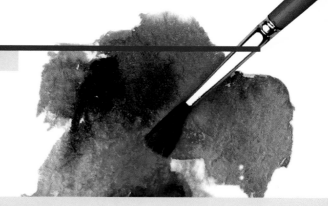

■ _HELPFUL HINT:_

As in the case of cloudy skies, the painting of rain falling is useless to try to copy. Observe the effects of color, of light and of movement of water in puddles.

2 The whole lower portion of the composition is treated with a very dissolved wash of carmine: over this wash I have painted the same color to construct the lights and shadows of the road. The trees are a greenish mass from which stand out some very intense tones. The dripping or the excess of humidity does not worry me because humidity is the starring player of this watercolor.

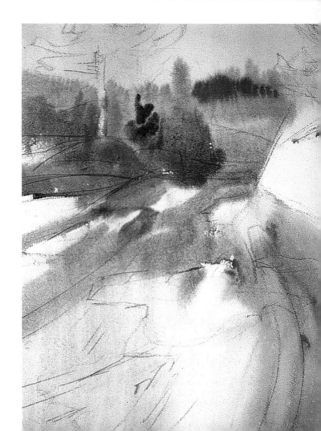

STEP-BY-STEP

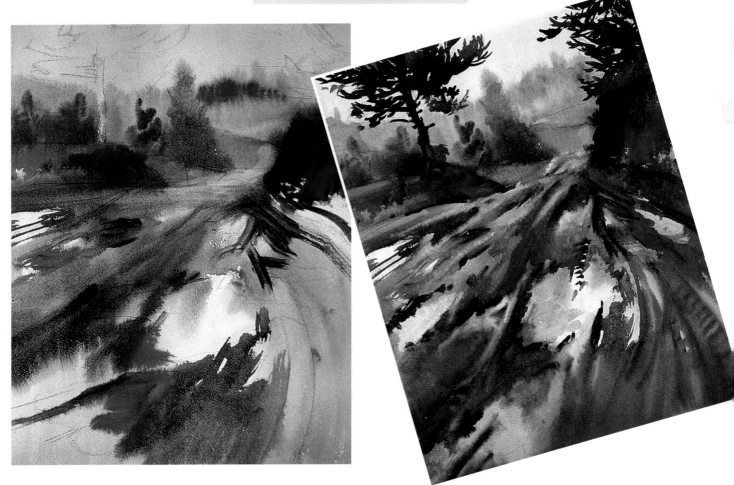

3 As you can see, I have approached the painting of the road with little trepidation. I use the most outlandish colors of the palette over the toasty Burnt Sienna, which I mix with blue for grays of different intensities. The distribution of the tones is in an impressionist mode, applying the strokes with independence from the form, following an initial visual sensation. This gives liveliness and mobility to the landscape that corresponds precisely with the sensation that I want to send out. I have saved some whites that will serve as the puddles.

4 I have left the last border very muddy and have contrasted it with the dark precision of the profiles of the tree. This tree is almost a pure silhouette, and thanks to the contrast, creates the sensation of a muddy screen that was mentioned in the introduction to this demonstration. The plain treatment of these forms, without modeling or mixes, forces me to give variety and strength to the outlines of the branches and leaves, so that they have a clear visual presence in the work. In the foreground, I have painted the tracks through long, very damp paint strokes, dark in color, leaving some broken.

5 The finished painting is shown on the next page. I have concentrated on giving the foreground major details. Now, with the watercolor finished, we can see the treatment of the puddles: the two largest, in the central part of the composition, are covered with a soft Burnt Sienna and gray wash that represents the reflection of the landscape over all. Finally, the rain stopped and I believe that the result reflects this moment.

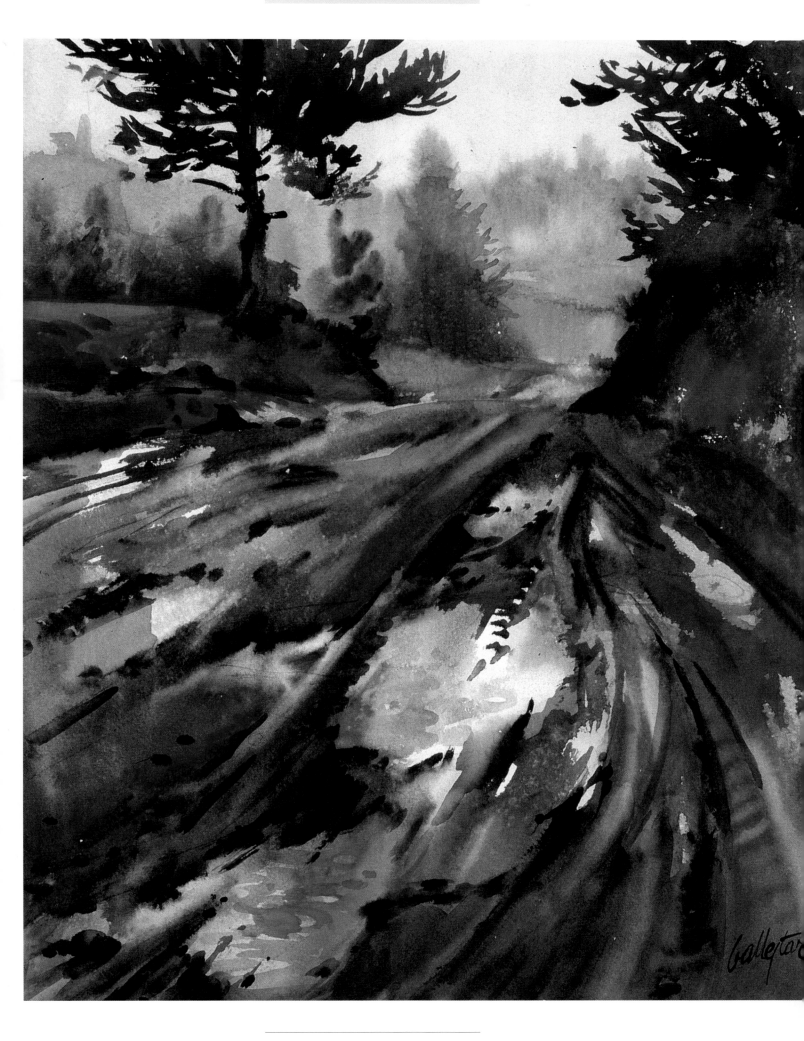

STEP-BY-STEP

Reflections on a Lake

To paint a river or a lake, you don't paint the water but the reflections on it. Depending on how these reflections are, the water will be calm or agitated, quiet or in movement. The chosen theme is of a tranquil lake, almost completely smooth, as shown in the photograph on the next page. When the water is a polished surface, the painter can come up with the softest, most transparent washes. Painting this type of theme is very agreeable, under the shade of a tree, feeling the breeze and letting yourself be carried away by the effect of the water. In these conditions, the watercolor landscape is a more gratifying activity than many you can find. Therefore, I have decided to do this demonstration as my final one in this book: The pleasure of watercolor painting has been my essential objective.

■ **HELPFUL HINT:**

It is easy to allow yourself to be carried away by the accidental appearance that takes the reflections over a moving or unmoving surface. But the reflections follow a determined order: the landscape (occupying approximately the same size that is occupied by the real landscape) and the current.

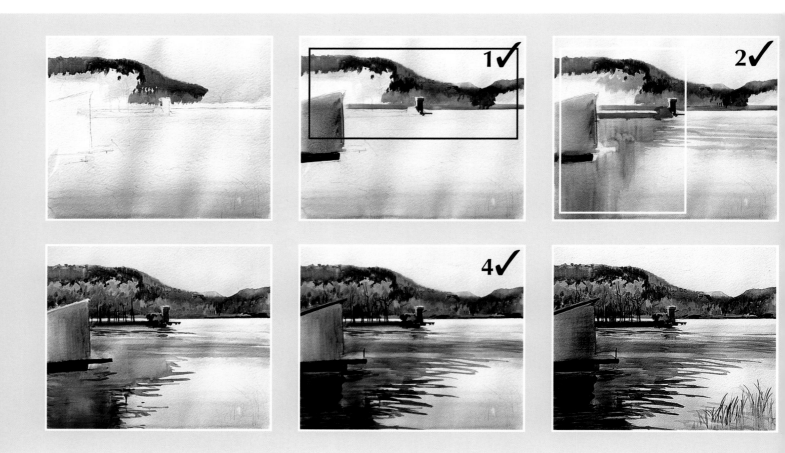

■ **THE PROCEDURE**

Here we see the mountains in the background, the two groups of trees, the riverbank, the pier in the background, part of the foreground pier, the reeds, and naturally, the water and its reflections. Although the sky of the watercolor is treated in wash, the final effect is of a space in white.

STEP-BY-STEP

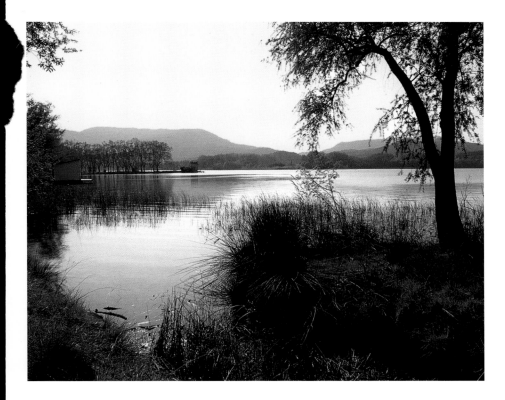

1 Behind the initial drawing and before working with color, I have extended a wash of a very pale green, very much dissolved in water, over the whole upper part of the paper up to the farthest bank. This wash will constitute the treatment of the sky. The mountains are carefully painted and lightly modeled with a base of gray blue paint strokes that brings out the presence of a densely treed area. Below these mountains I have painted the trees from the bank with greens of a yellowish hue to pose a sharp contrast.

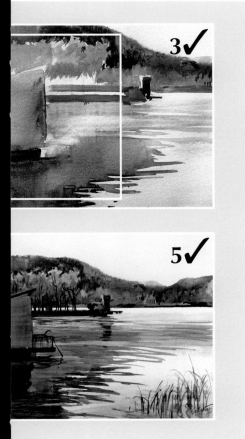

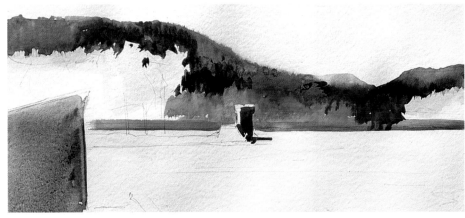

2 The boathouse on the right is painted with a gray wash and under its base I have put in a dark stroke to represent the pier. The way in which I have extended the first wash, which will be the surface of the lake, can now be seen. It is treated with a greenish blue that doesn't cover the whole surface of water but only the upper left angle, the most shaded place. In the most distant part of the lake I have drawn the first lines.

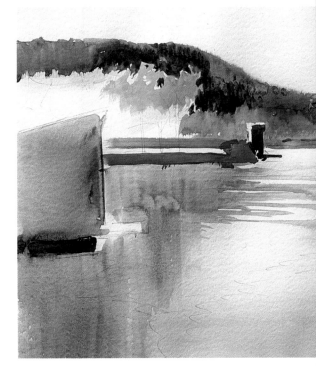

STEP-BY-STEP

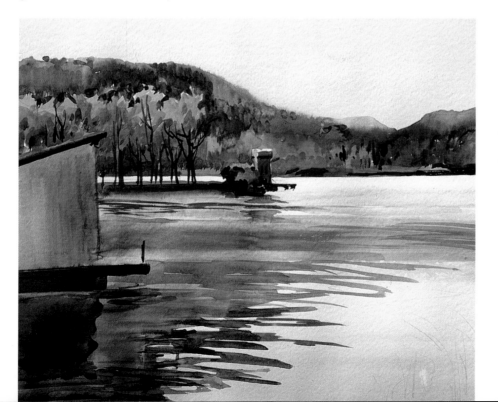

3 I have painted the trees from the pier of the background using a warm greenish yellow, creating a luminous and very contrasted color that I will mix and model into light and shadow. The shadows and reflections of the water have a more peppy appearance due to the impact of the color. I have drawn dark enough lines and later have fused them in a color in which the extremes of those lines appear in clear contrast with the illuminated surface.

4 I have worked the trees, so the farthest ones, like those near the pier, blend the yellow color base with dark greens. Their lower part is blended with the bluish background of the mountains. The lake water has received a more precise treatment: between the washes of the first level one can see distinctions of value that create the shadow of the boathouse and the movement in the surface. The reflections of the pier in the background are painted with a greener color.

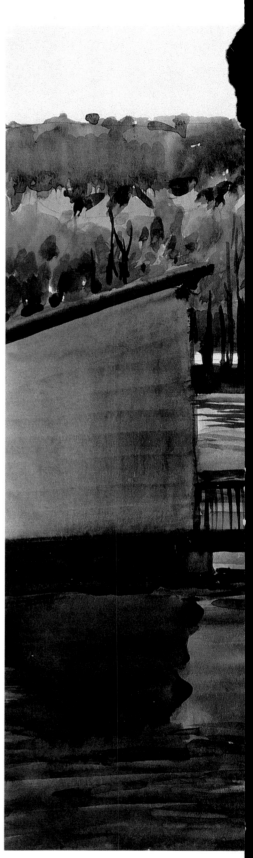